평양에 온것을 환영합니다.

Welcome to PYONGYANG

CHARLIE CRANE

Introduction by Nicholas Bonner

With the new millennium, the Democratic People's Republic of Korea is continuously visited by a growing number of foreign tourists. Curious tourists may have many things they want to know, see and learn about Korea. Korea has diligent and honest people whom are advancing full of hope and enthusiasm, proudly creating a modern history in single-hearted unity around their Leader.

There is a Korean saying that seeing is believing. Although you may be acquainted with Korea through books or media it would be better to come and see the actual Korea for once. Korea is not yet well known for tourism. Foreign tourists, however, visit the DPRK and are impressed by kind services and hospitality.

Welcome to Korea.

National Tourism Administration Guidebook, Juche 91 (2002)

Introduction
Nicholas Bonner

The Democratic People's Republic of Korea (DPRK) has not forgotten the Victorious Fatherland Liberation War between 1950 and 1953. Known elsewhere as the Korean War, within the DPRK it is regarded as having been started by the United States. No peace treaty has ever been signed. The Korean peninsula, and Korea itself, remains divided by the 4 kilometre-wide Demilitarized Zone, physically and ideologically separating the north from the south. You might be forgiven for thinking the DPRK might not be the ideal place for a vacation.

But travel to the DPRK is neither dangerous nor difficult. For those who have come as tourists, it ranks amongst the places they have most enjoyed visiting. Tourist visas are not issued to journalists or photographers, and citizens of the USA and Israel are only rarely granted visas. But for the rest of the world, the doors are open. If you are prepared to comply with the regulations (including the photographic restrictions and the obligation to stay with your guides when outside your hotel) you may experience the kind of safe, organized guided tour that you would expect on any all-inclusive package holiday. You also get exposure to the single most unique society in the world.

Although the Korea International Travel Company was founded in 1953, tourists from Western countries did not begin to come to the DPRK until 1986. Today, around 1,500 Westerners visit annually – similar to the number visiting an English seaside resort on a wet weekday. Chinese mainland tourists on the other hand come in their thousands. There is little background reading that will help prepare you, or that would enhance your experience. You would be better advised to travel with an open mind; to observe and hear the world presented to you from the DPRK point of view, including their commentary on who started the Korean War and why the USA is seen as such a threat.

Travel to the DPRK is a procedure-heavy challenge comparable with applying for a new job: you apply four weeks in advance and are required to provide both a curriculum vitae and a company letter. Visa issued, your choice of entering the country is between the 24 hour sleeper train from Beijing or the 90 minute flight

평양에 온것을 환영합니다.

from either Beijing or Valdivostok on the classic Russian Ilyushins and Tupolevs of Air Koryo. Once you've landed at Pyongyang's Sunan International Airport, or have crossed the northern border by rail into the city of Sinuiju, you are in another world.

Two Korean guides and a driver meet all solo and group travellers on arrival. They are responsible for you and will accompany you throughout your stay. Your first contact with the guide will be the ubiquitous greeting, 'Welcome to Korea' – or in the capital, 'Welcome to Pyongyang' – and a statistic-filled lecture about the DPRK, Pyongyang's 5,000 year history, 70 square metres of green space per citizen etc., etc. After 30 minutes this list of statistics finally dries up and it is then that the tour changes from the one you expected – a guided tour led by automatons – to one which is genuinely pleasant, each guide with their own personality wanting to know as much about you as you do about them – albeit with a few compromises required along the way.

The majority of tourists see the guides as surprisingly open and genuinely friendly. Others regard them as minders, there to restrict tourists to a pre-arranged itinerary and prevent all independent thought or action. There is truth in both versions, but how your trip goes depends on your rapport with your guide. The guides are not there to brainwash and convert you to their cause. They are simply there to show you their country's achievements. Respect this and you will find yourself seeing and hearing more than you thought possible. But remain closed, or breach the clearly proscribed protocol, and bang go your chances of discovering anything beyond the confirmation of your preconceptions.

The young guides of today have either graduated from Kim Il Sung University or the Tourism University and are trained in the art of hosting, chaperoning and managing Western tourists. They tend to adopt the idiosyncrasies of the foreign language they speak: the Chinese-speaking Koreans are relaxed, joke around the most and are all karaoke kings; the European guides have a dry sense of humour but have a more difficult job. Western tourists under these laboratory conditions

are simply not as easy to handle as the Chinese.

Guides can do the impossible. I've known them to wave off tour groups at Pyongyang train station only to find they had forgotten to give back the passports – and yet the passports were handed back to the tourists at the border. They can sing and drink until the early hours but will still be up at seven the next morning for the day's touring, and able to deliver the unending list of revolutionary facts and figures flawlessly. They invariably earn the affection, admiration and respect of their charges.

In comparison to other rapidly reconstructed post-war cities, Pyongyang is a surprisingly beautiful and photogenic place. The fact that the city was entirely levelled after the Korean War gave urban planners a blank slate for constructing their socialist utopia. Pyongyang has everything a centrally planned city requires, lifted straight off the drawing board and into reality. The Taedong River cuts through the centre of the city; it is so cold in winter you can walk across from Kim Il Sung Square direct to the Juche Tower, while in summer it's warm enough to swim across. There are intimate places for couples along the Potong River to sit and smooch DPRK style, and spaces such as Kim Il Sung Square that dwarf you unless you happen to be involved in one of the many mass dance soirées.

There are enough monuments, museums and historical and revolutionary sights to keep you occupied in Pyongyang for several revolutionary weeks, but a short visit is enough to build up a general picture. The majority of these are dedicated to the late President Kim Il Sung and the Juche Idea – the DPRK's state ideology. The Juche philosophy, loosely translated, is that man is master of his own destiny – a departure from Marxist–Leninist dialectical materialism, differentiating North Korean socialism from other models.

Your tour guides spin you around the city on a pre-planned itinerary. They deliver you into the arms of local guides who are responsible for individual monuments and museums. These local guides, normally female and traditionally dressed, go into laborious detail about the site you are visiting – often the

minutiae of its construction ('the Arch of Triumph is 60 metres high and 52.5 metres wide, and built of 10,500 granite blocks', etc.), peppered with anecdotes about revolutionary heroics. They are eager to answer any question fired at them, although it is most unlikely that you will have a statistical question that isn't already covered in the talk.

Tour schedules take you from the stunning architectural forms of Sports Street – with its buildings designed to reflect the sport they house – to a cold shave with a guillotine razor at the Changgwang Health Complex. You travel on the metro through stations named 'Restoration' and 'Glory' – riding its East German rail stock – and wander through Moranbong Hill trying to avoid picnicking locals with their home-brewed soju and their invitations to dance. An afternoon is spent visiting monuments such as the Grand People's Study House, for a little light reading among its 30 million books, followed by a potter around the Central Art Gallery comparing ancient copies of tomb paintings with the latest propaganda artwork. If you have a strong constitution you can squeeze in room after room of performing children at the Mangyongdae School Children's Palace, although this may put you off Japanese-made keyboards and drum sets for life. But you can't help being fascinated by the five storey high chandeliers made at the Nampo Glassworks Factory or the kimchi containers produced at the Disabled Plastics Necessity Complex.

The tree-lined streets are quiet, almost deserted, especially on a Sunday which is a 'no traffic day'. Meanwhile on any of the many national days, you face tens of thousands of people on the streets in parades bursting with plastic flowers and pom-poms. For the quiet traveller this might be an appropriate time to make a break for the captured 'spy ship' USS Pueblo, moored on the river, to be escorted by one of the naval officers who as a young man in 1968 was part of the boarding party that seized the ship and its crew.

The itinerary might seem seamlessly controlled, but there are plenty of opportunities to break out of it and into a world of chance happenings and

encounters. Once outside the museums and monuments, you do have the chance to interact with Koreans, although how much depends on the trust and rapport you have built with your guide and how willing you are to make an effort to engage. I once started a giant football match, with hundreds of participants, simply by kicking a ball back to one kid at one of the schools we visited; sung out-of-tune karaoke with a colonel in the Demilitarized Zone; danced appallingly badly in front of an audience of 60,000; and rode the horrendous 'wheel of death' at Taedong Funfair. Travel in the DPRK is anything but normal. It is unlikely to transform all your preconceptions but it will certainly captivate you and open your mind. There are only a few visitors who fail to experience something of everyday life and humanity beyond the tour itinerary, or who cling to the apocryphal tales that there are no pregnant women, only actors on the subway, or that no one smiles.

In 1993 Koryo Tours was established to run trips to the DPRK. We have made three documentaries and several radio programmes, but producing a photographic record that respected the unique conditions of the country was a particular challenge. Photography in the DPRK is a strange beast. Koreans are anxious to show off the best of themselves and their country at all times. This can lead to farce as people overcome their nerves and compete to have their picture taken, or refuse permission based on seemingly innocuous details such as having a missing button. Pyongyang citizens use cameras as a way of recording themselves at particular points in time and often at a place of significance – for example, a wedding group at the Workers Party Monument where Government photographers will take the picture for a small fee. For photographs taken at locations such as the zoo or even on Kim Il Sung Square, they use kitsch props such as stuffed horses, flower arches and teddy bears.

If a family is fortunate enough to have a camera it will be used for formal portraits. Frames are not wasted on informal snaps. There is no camera culture and film development costs are expensive, although the number of digital

cameras in circulation is growing and may lead to a more informal approach. Family albums record major events such as birthday celebrations, university graduations and grandparents in front of tables laden with gifts on their wedding anniversary. For a group scene, the photographer asks his subjects to say 'kimchi' – the national dish of pickled cabbage – which reliably brings smiles to their faces. Photography for public exhibition is used to pay respects to the Leaders and to demonstrate the allegiance and support of the public and army in the various construction projects around the country. There are no photography exhibitions at the National Art Gallery for aesthetic purposes only. Photography is not regarded as an art form in its own right.

Tourists often find that the restrictions on photography are not as intense as they initially thought. Memorably, in 2002 one of our tourists came across a platoon of soldiers marching down a broad avenue. Fearing a telling off, he kept his camera in his bag and backed away from what appeared to be the entire Korean People's Army. From a safe distance he braved a little wave, and without breaking step the entire platoon waved back for a picture. Nevertheless, it is almost impossible to get beyond the vision of the place that has been so meticulously crafted.

What we present in this book is Pyongyang on its own terms. Charlie Crane and I have accepted, even embraced, the limitations placed upon photography. We hope the result is as interesting and revealing as any undercover photo-essay. I make no apologies for presenting it this way. Visiting Pyongyang is a unique and rewarding experience, and I urge anyone who has the opportunity to see it for themselves.

Beijing, December 2006

View from the Juche Tower

The Viewing Platform of the 150 metre-high Juche Tower gives one of the best views of the city. Here we are looking at East Pyongyang district. This is mainly a residential area and you can see the standard of apartment buildings of most people in Pyongyang. The Juche Tower is a symbol of the philosophy of the Great Leader Comrade Kim Il Sung. 'Juche' is the guiding principle of our society. Thanks to the great efforts of our President Kim Il Sung, our people became an independent nation, free from the flunkeyism, dogmatism and oppression which had bound our people for centuries.

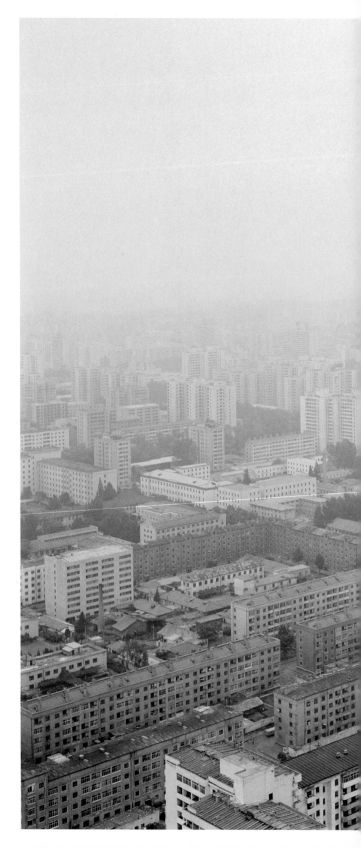

평양에 온 것을 환영합니다.

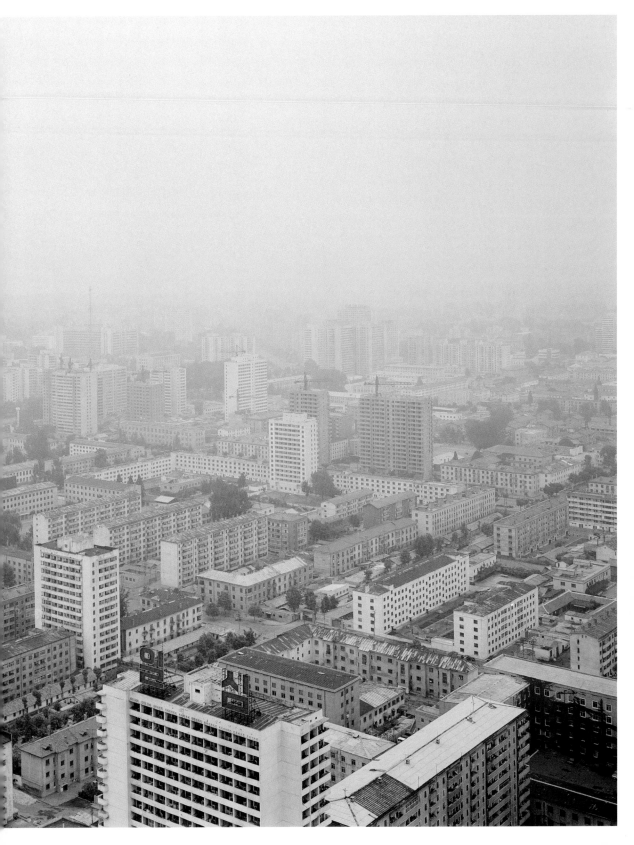

Thongil Street

'Thongil' means reunification and if you follow this street south and keep on going you will arrive in the southern part of Korea. Along the street are sculptures depicting the ardent wish of the Korean people for the final unity of our nation. It is down this street that we had reunification marches with our countrymen from the south. The street is 100 metres across, making it one of the widest streets in our country.

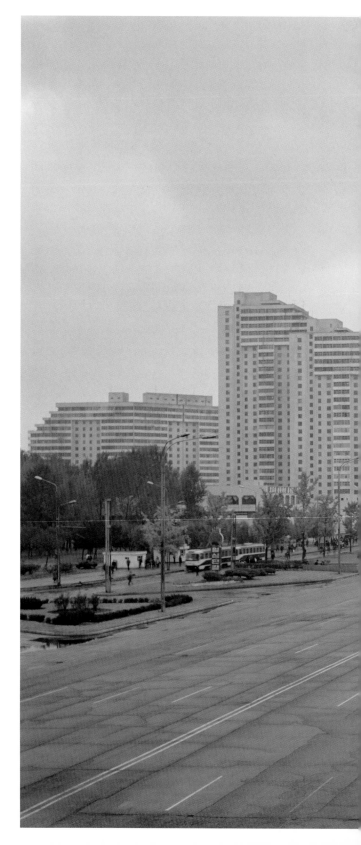

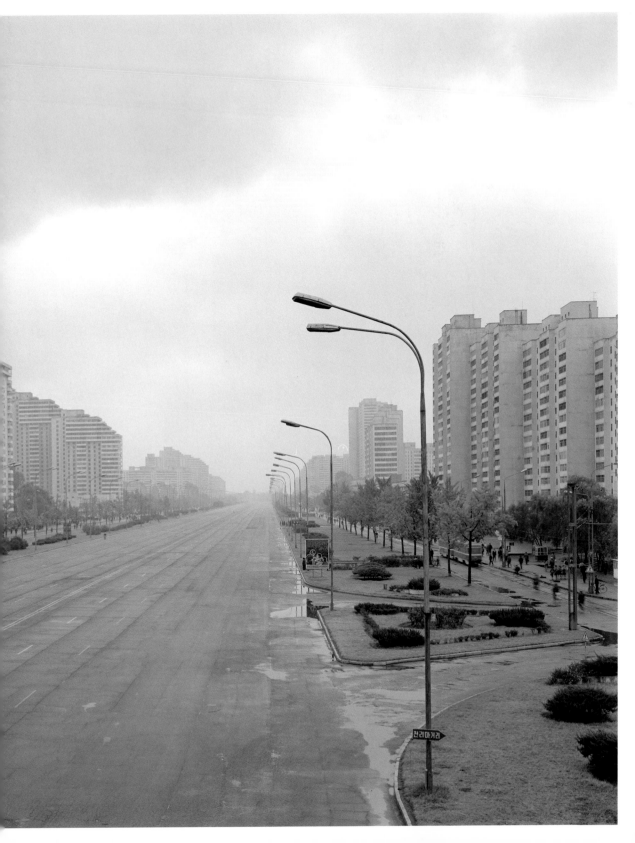

Moranbong Middle School Number One

This is the playground of the Moranbong Middle School Number One. The main building has six floors and all subjects are taught in here, including English which everyone must study. School starts at 8 am and ends at 1 pm. After-school activities take place in the afternoon. In the DPRK children go to school from age six to sixteen, and then usually to university or to the army afterwards. Some women choose to join the army though it is not compulsory. On top of the block of flats is the slogan 'Independence, Peace and Friendship', which is lit up at night.

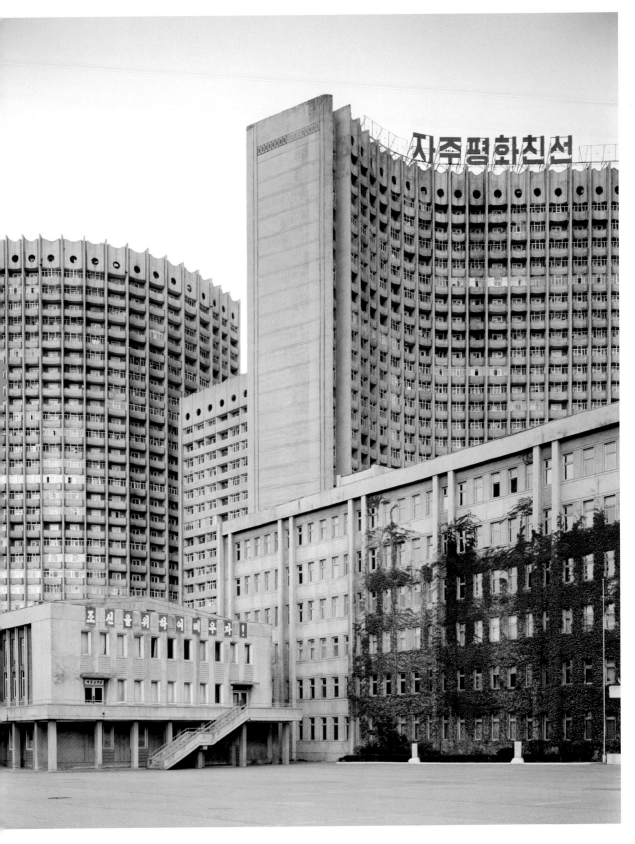

Moranbong Middle School Number One

Student Kim Chun Hyo is on his break time and he is wearing the standard school uniform and school badge. Each badge has the name of the school written on it under the Juche flame. When he is older he would like to be a sportsman in basketball or football and he is trying to get good grades to get into the Sports College.

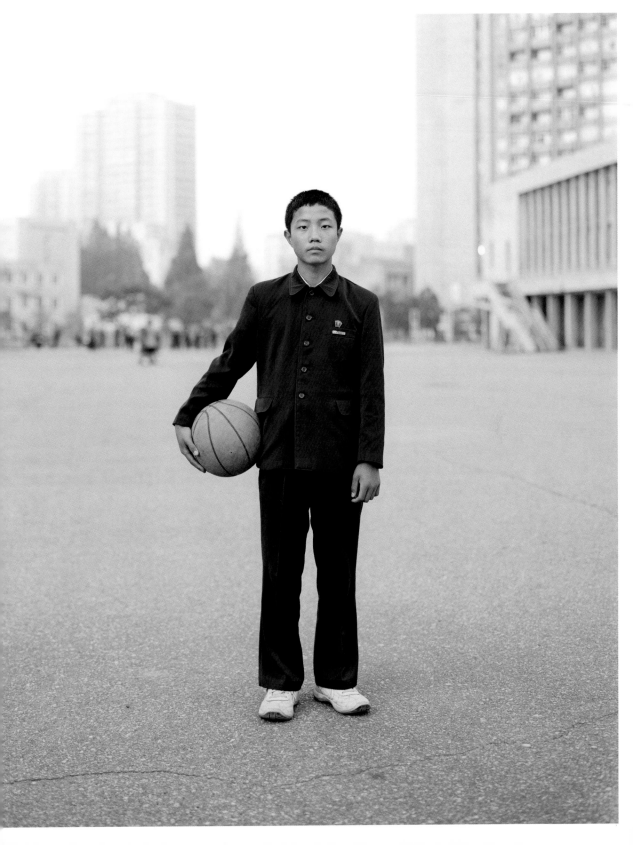

Table Tennis Gymnasium

Li Hyon Hui goes to a normal school but she has a talent for table tennis. She wants to play for our national team and bring glory to our country. She goes to the table tennis gym practice every afternoon, except on Sundays, and also practises at home against her bedroom wall. The building behind her is the Table Tennis Gymnasium and it is shaped like an enormous concrete table tennis net. Inside it is full of table tennis tables and has seats for an audience of over 4,000 people.

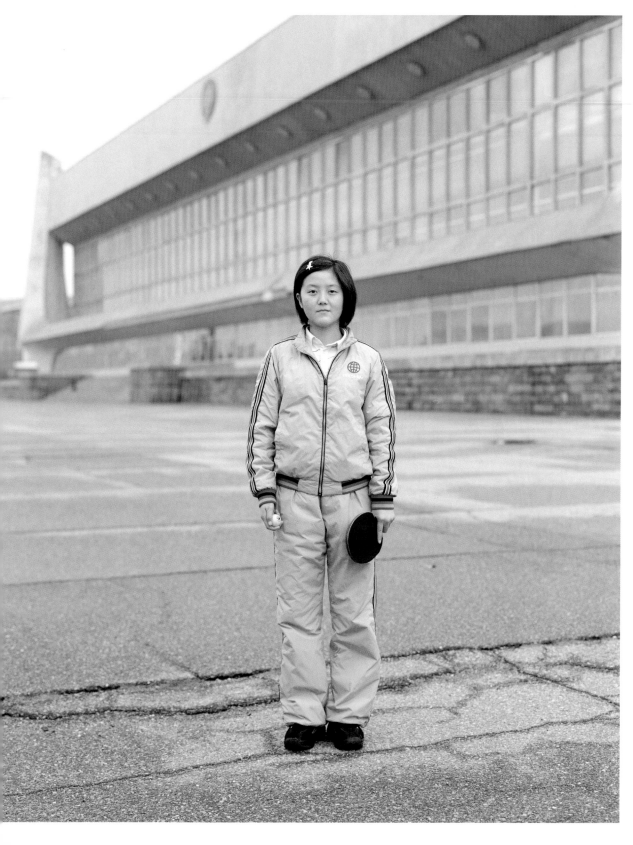

Meari Shooting Range

In the 2004 Olympics in Athens, Kim Jong Su won a silver medal in the shooting events. It is at this shooting range that she perfected her ability. You can use pistols and rifles here – low-calibre sports weapons, not the same as used by the army! Ho Sung Ae has been working at the shooting range for six years as an assistant. She served in the Korean People's Army for three years and was selected for her good shooting skills. She often gets 30 marks with three shots, the maximum possible. She is working towards being a shooting teacher but is now 28 so will soon be married.

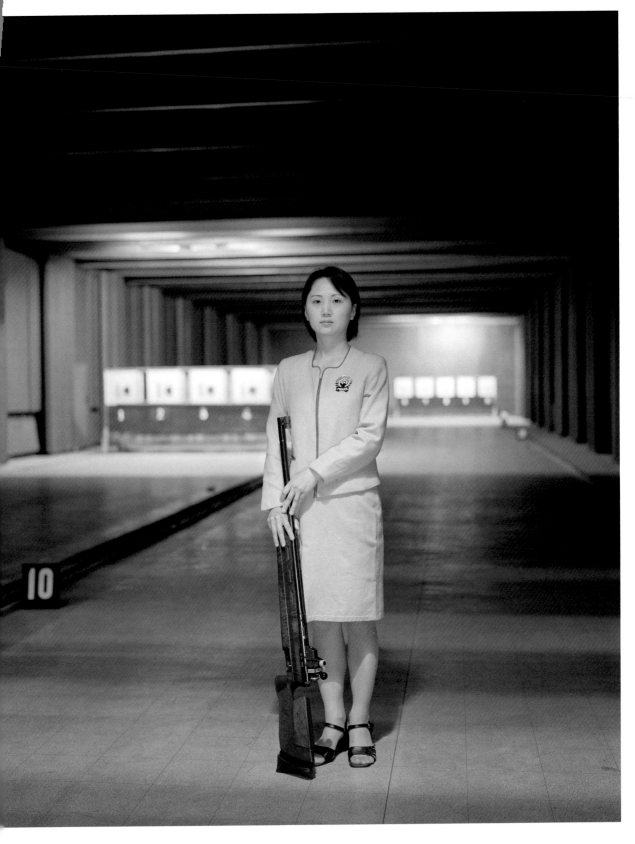

The Pyongyang Art Gallery

The Pyongyang Art Gallery is on Kim Il Sung Square, the very centre of our city. It is a place people really love to visit as it shows the many different styles of art produced in Korea, from many different eras. The contemporary gallery has work from our Merited Artists and People's Artists who produce the best art in our country today. I recommend all visitors to come here. It really must be one of the best galleries in the world. The poster behind the guide is promoting the 60th anniversary of the Workers' Party of Korea.

평양에 온것을 환영합니다.

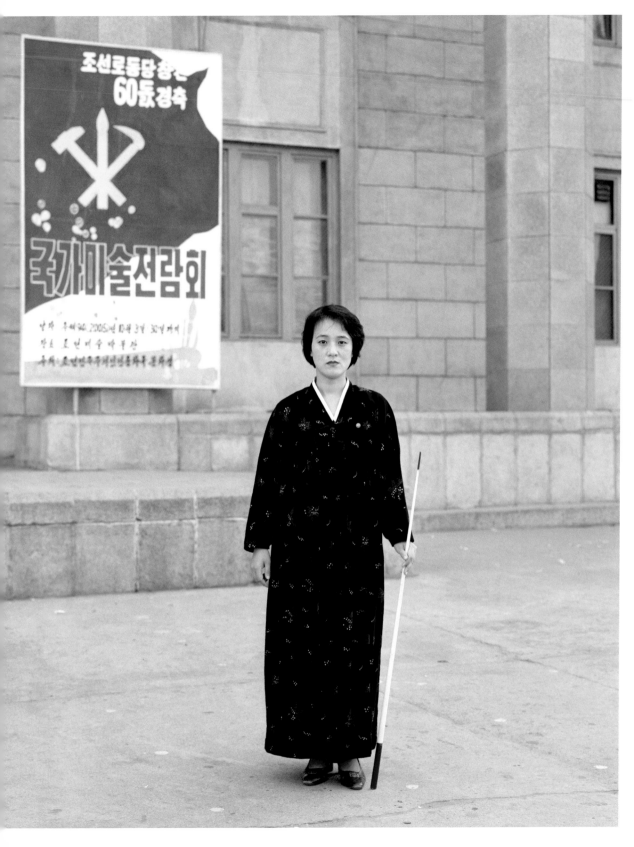

The Korean Folklore Museum

The Korean Folklore Museum shows artefacts from the ancient past of our country. We are very proud that we have over 5,000 years of history. Korea was a unified country with common language, culture and blood before the division by foreign forces in 1945. Every Korean's strongest wish is for the peaceful reunification of our country. Mrs Lim specializes in Korean folklore and she explains the history, customs and culture of our country.

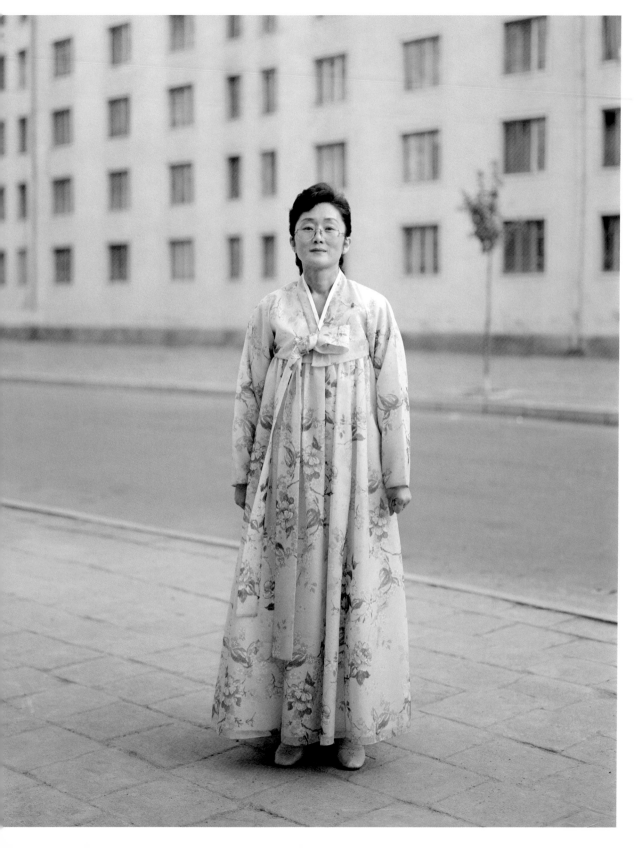

Mansudae Fountain Park

In our country people get married throughout the
year but there are certain times that are favoured.
It is very auspicious to get married on national
holidays, such as April 15th – the birthday of the
Great Leader – and also at times of convenience
such as Sunday when friends are off work. It is
common for the bride and groom to spend the
day touring the famous monuments and sites
of Pyongyang having their portraits and videos
taken for their memories, like at the Juche Tower
or Mansudae Fountain Park. This couple met at
their work unit. In the old times parents introduced
couples to each other, but this is not so common
now. Myself, I met my wife at work and by accident
we fell in love.

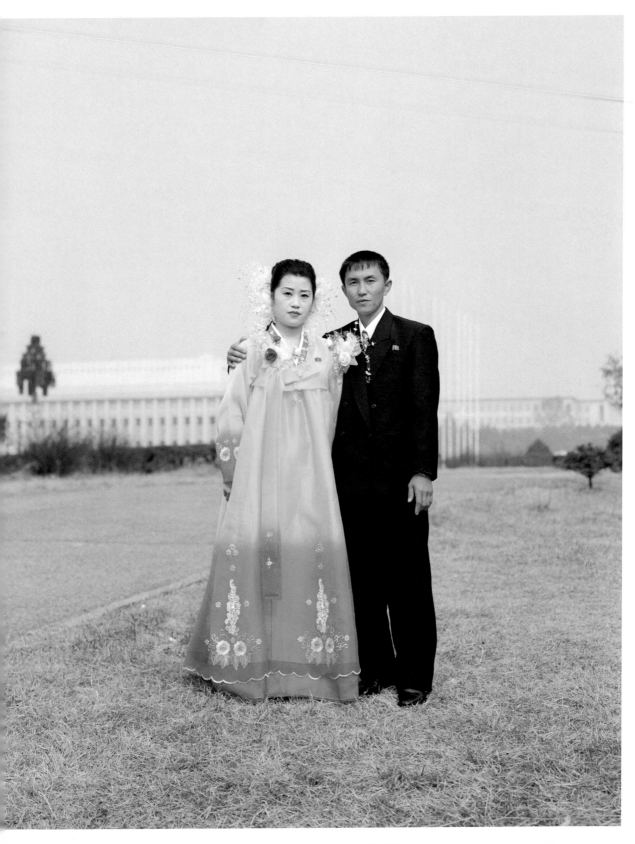

Pyongyang Maternity Hospital

Pyongyang Maternity Hospital is the most famous hospital in our city and is situated in the eastern part of Pyongyang. A great many babies are delivered here each year, including the children of foreigners such as diplomats who live in Pyongyang. Dr Yun is 30 years old and is an obstetrician at the hospital. He studied medicine for nine years. We have well-trained medical professionals in the DPRK as we place a great emphasis on a healthy life for the people. Medical care and treatment is provided free in our country.

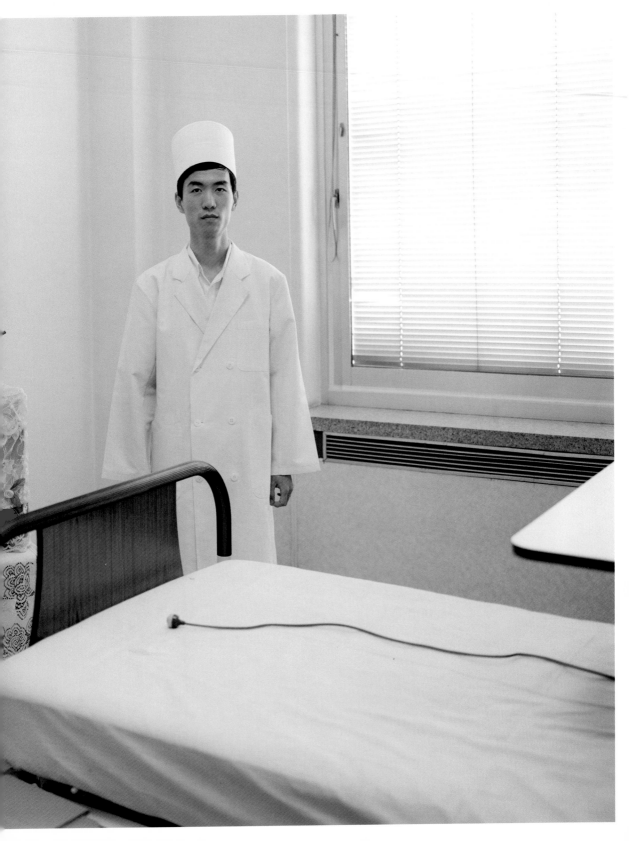

Central Zoo

Although a lot of animals in the zoo are native to our country, such as bears, tigers and deer, we also have a lot of animals that were given as gifts from foreign leaders and notable people. The zoo is a very popular place for families to visit, especially on national holidays. Miss Mun has worked at the zoo for three years, since she graduated from the animal faculty at Pyongyang Agricultural College. She is standing by a cage of cats. Although some people keep cats as pets, we also have many cats in the zoo. Foreigners think this is strange but here we are able to show many breeds of domestic cat from around the world. This is also one of the most popular parts of the zoo – especially for little girls.

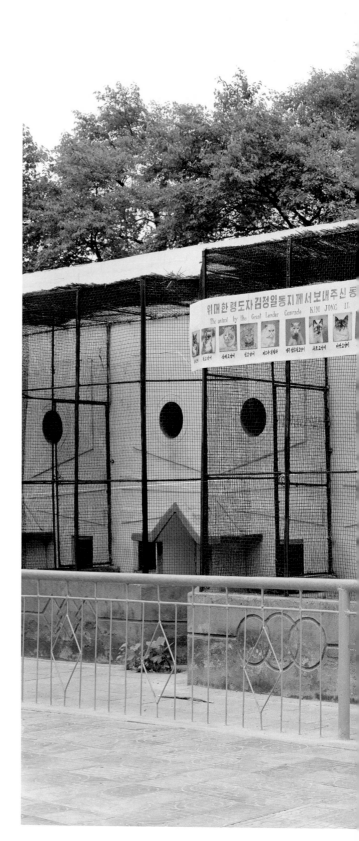

평양에 온 것을 환영합니다.

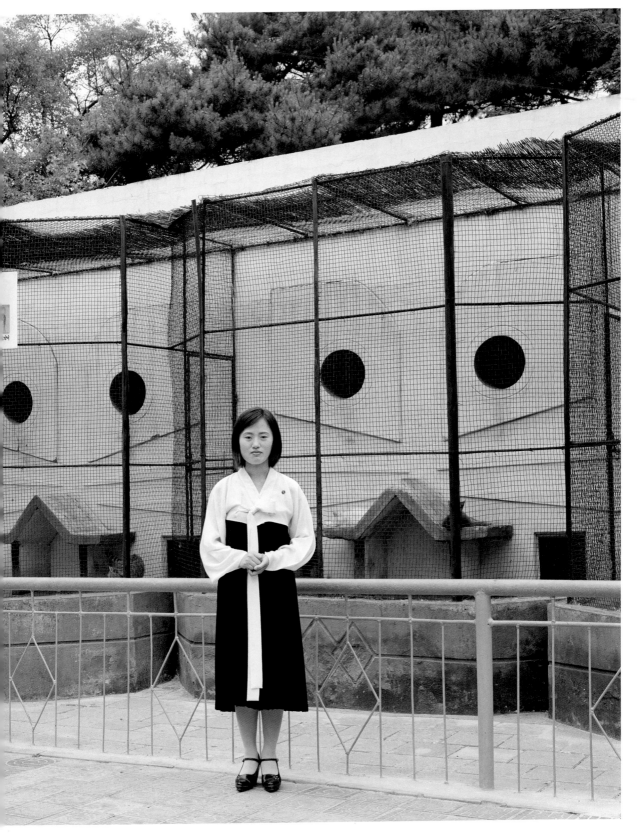

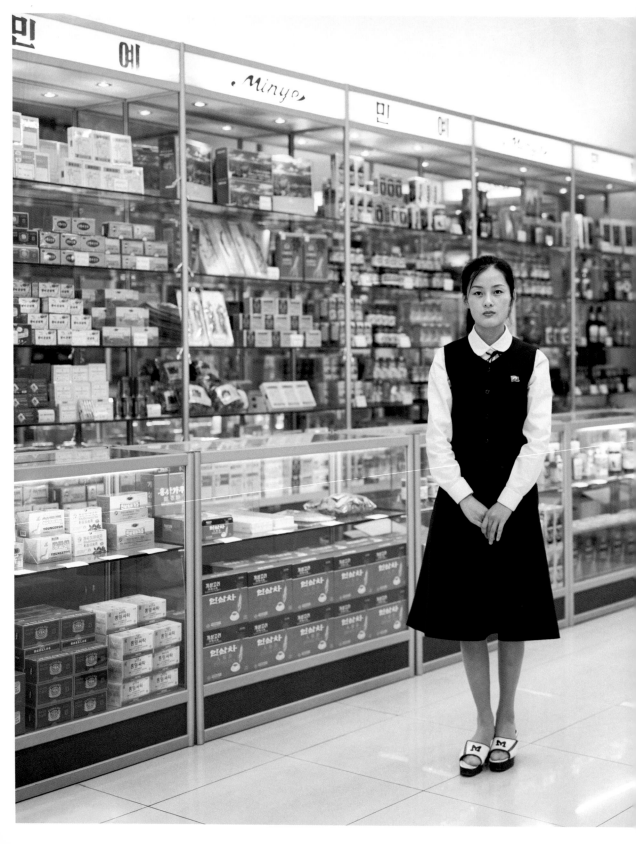

Minye Souvenir Shop

This is 25-year-old Miss An Gyeung Ae who is a sales girl at the Minye shop which is an outlet for all sorts of Korean products including musical instruments, sculptures, fine art and ginseng. She has spent three years working in the shop serving both local and international customers. She says the ginseng cosmetics and ginseng tea are very popular with tourists from the south. Our ginseng that grows in Kaesong is recognised as the best in the world and can cure many ills, and keep you living long and in the best of health. Western tourists prefer small things such as our brass chopsticks and bowls and little cloth Korean dolls. I think they do not have a lot of room to take things in their luggage on their flight home.

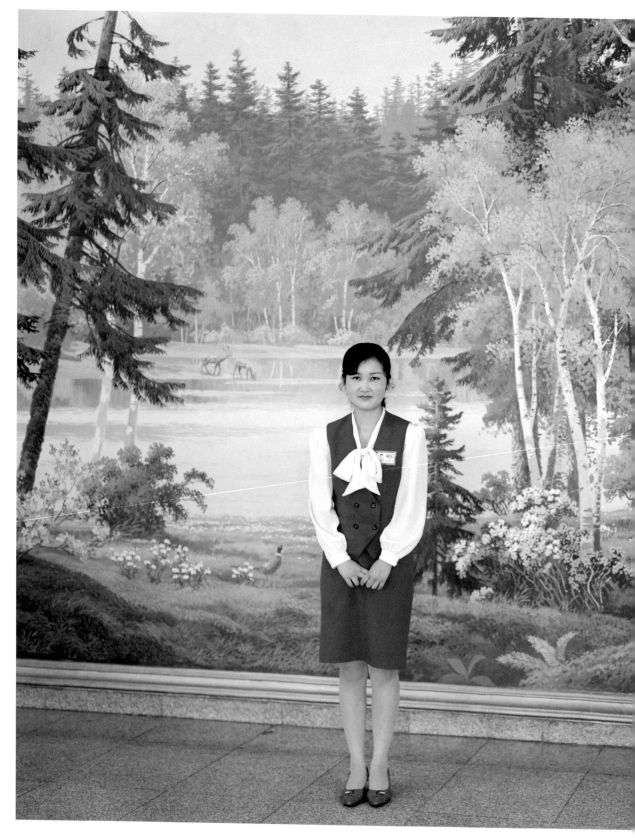

Number One Duck Barbecue Restaurant

One of my favourite restaurants in Pyongyang is the Number One Duck Barbecue Restaurant on Thongil Street. By a lucky coincidence, it is near my house! The specialty here is duck, of course: boiled duck, duck dumplings, duck balls and barbecued duck in the Korean style which you cook yourself on the barbecue at your table. Here they also serve Taedonggang beer which is the best beer made in our country. This is a popular restaurant for Koreans to visit on special occasions, for parties with family and friends. The waitress is a graduate of the Cookery College where she studied for three years. If you want to call her over you say 'Chopdaewon dongmu', which means 'Comrade waitress'. The background mural is of a lakeside scene typical of the countryside in the northern part of Korea. It reminds me of the famous Lake Samji where the guerrilla army fought the Japanese in the 1930s and 1940s.

Embroidery Institute

This is the sales room at the Embroidery Institute where we sell embroidered pictures to tourists. Embroidery has been a Korean tradition for interior decoration from medieval times. Tigers, dogs and cats are popular subjects, as well as landscape scenes and beautiful flowers. Embroidery is done by women and the very best artists will become People's Artists, a top award in our country. In my home we have some embroideries as decoration. Mrs Li Wol Sun is the highest Merited Artist in embroidery and she has over 30 years of work at the Institute. She is Artist Number Two grade which is the highest rank. There is a Number One rank, but no one has ever reached it because of the eye strain – one of the dangers of doing too much stitching.

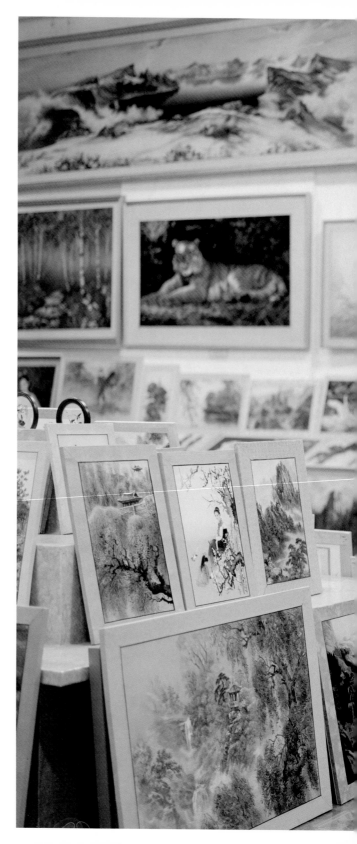

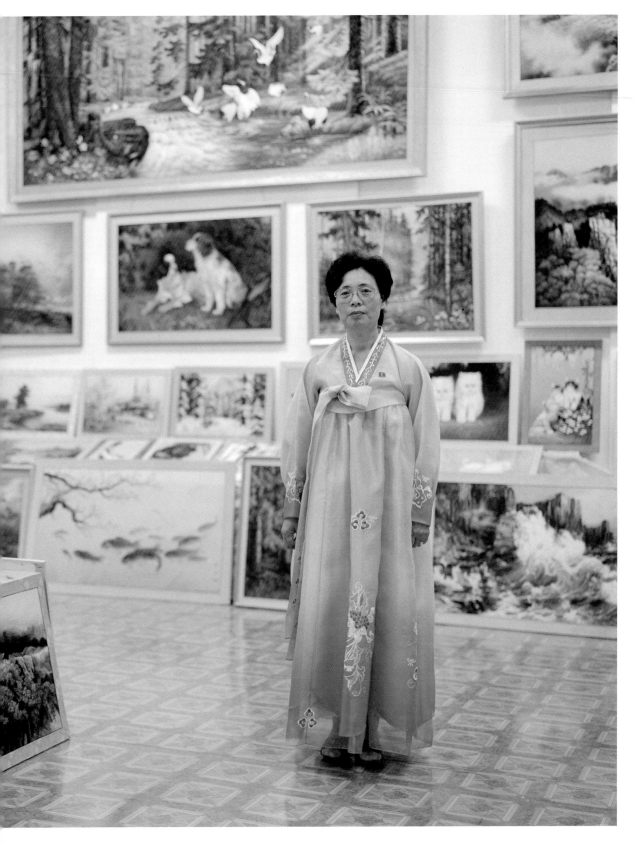

Mansudae Art Studio

Mansudae is the most famous art studio in our country. It is where almost 4,000 artisans work to produce our country's famous artworks and sculptures. Since early times we have been famed for our celadon pottery and this waxwork is of potter Mr Wu Chi Son who was born in 1919 and became our most celebrated maker of celadon pottery. The waxwork was made in this Art Studio and is so realistic it shocks people: even if they look at it for a long time they still think he is real and will speak to them. Mr Wu showed his work around the world and became an honorary citizen of Osaka in Japan. This is the showroom of the Studio and the paintings are by our most loved artists.

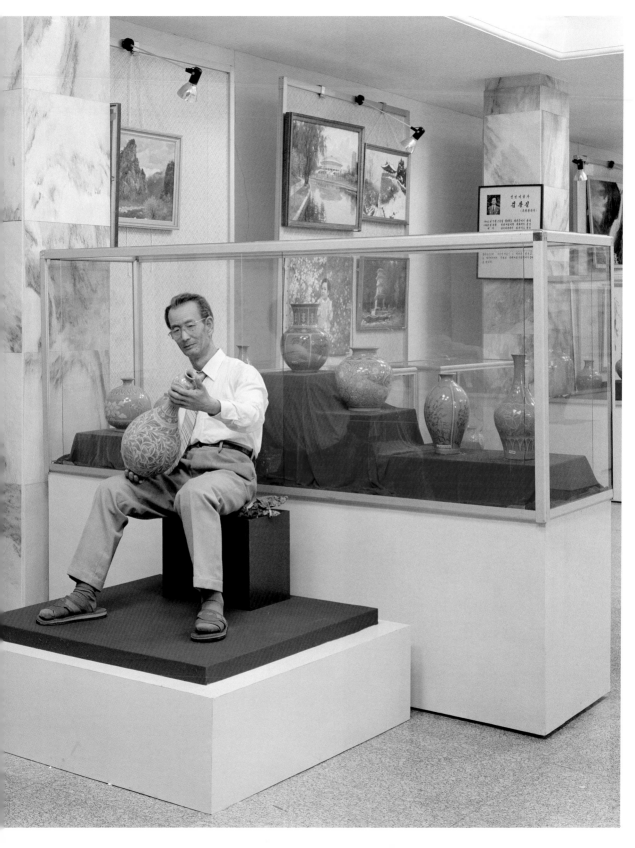

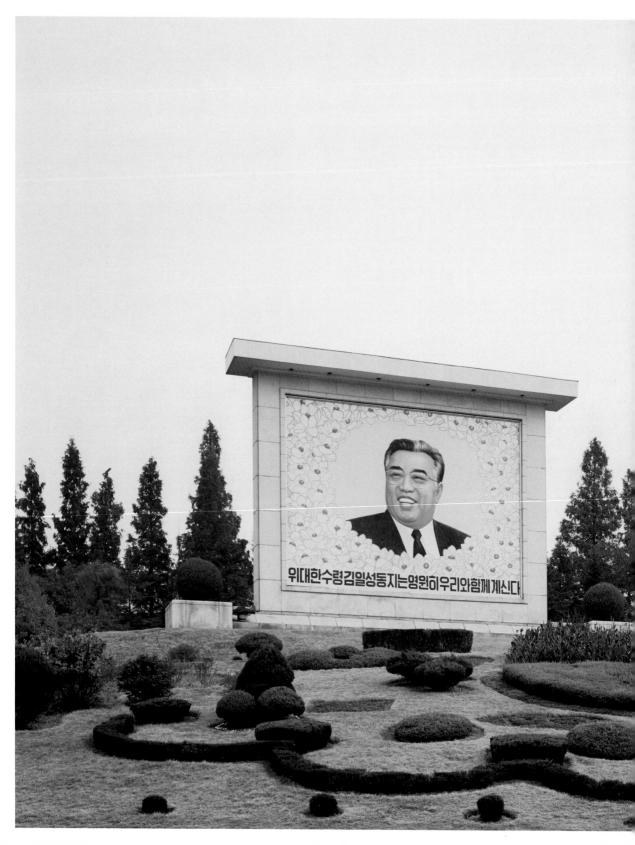

Mosaic Portrait

All over Pyongyang you can find large mosaics created by Korean craftsmen and women. These often depict our Leaders and are very skilfully designed and produced. This mosaic is near the centre of the city and it shows our President Kim Il Sung surrounded by magnolias which are the national flower of the DPRK. The slogan in Korean characters reads 'The Great Leader Comrade Kim Il Sung Is Always With Us'. Although he passed away in 1994, we still consider that he is with us as we follow his teachings and policies and keep living the way he wanted.

following pages

Grand Monument, Mansudae Hill

This monument is the first thing people want to visit on their return after they have been travelling abroad. The majestic statue of Comrade Kim Il Sung is looking far ahead with his right hand indicating the way forward. It is such a special place to us Koreans – you cannot imagine how special. We come here throughout the year and often bring flowers, especially on the day of his birth which is the most important day of the year. The mosaic behind is of Mount Paekdu and the statues at the side show the immortal history of the revolutionary struggle – fighting the Japanese occupation, rebuilding the country on socialist principles and beating the US aggressors in the Fatherland Liberation War.

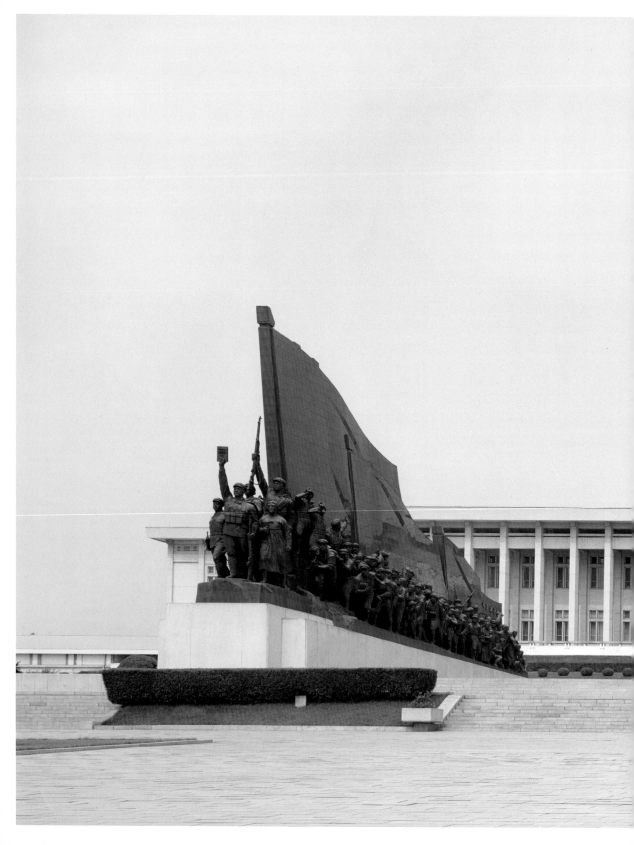

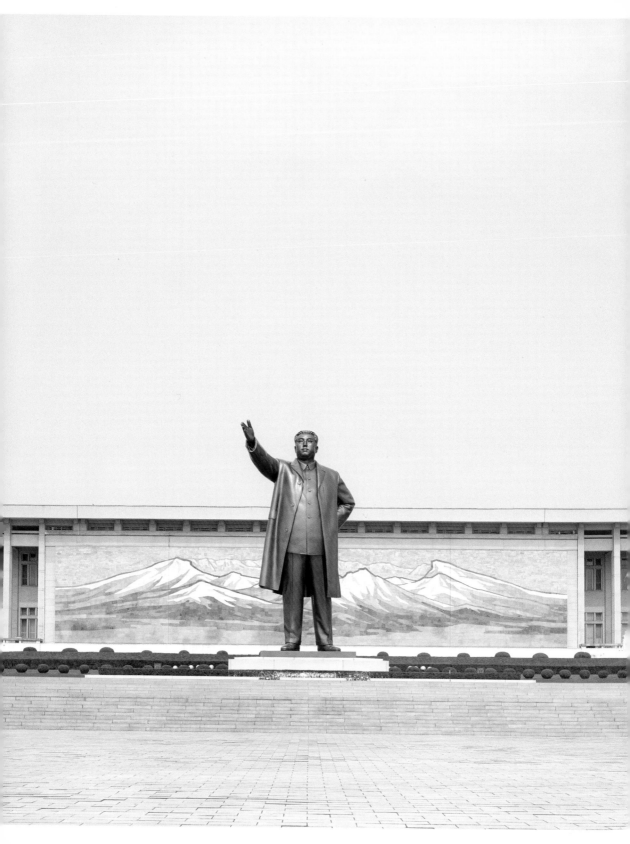

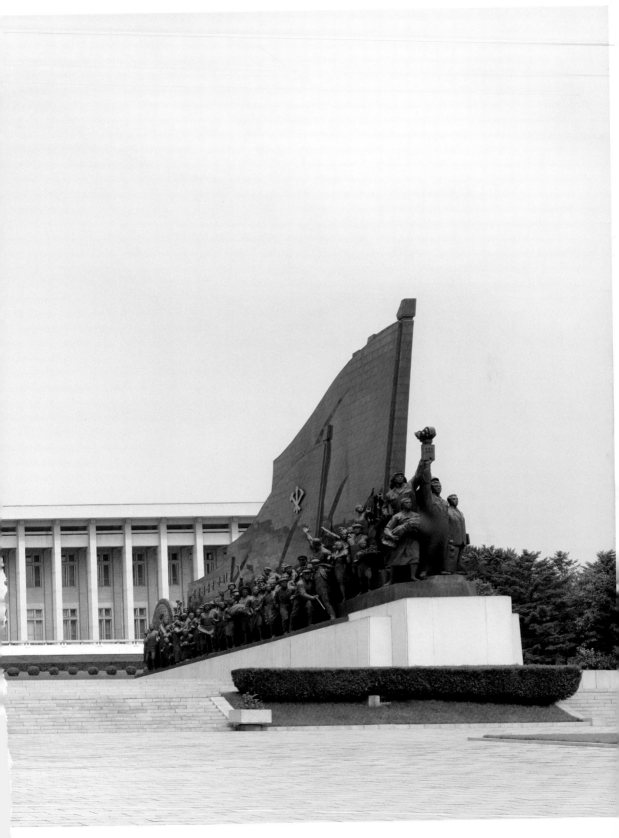

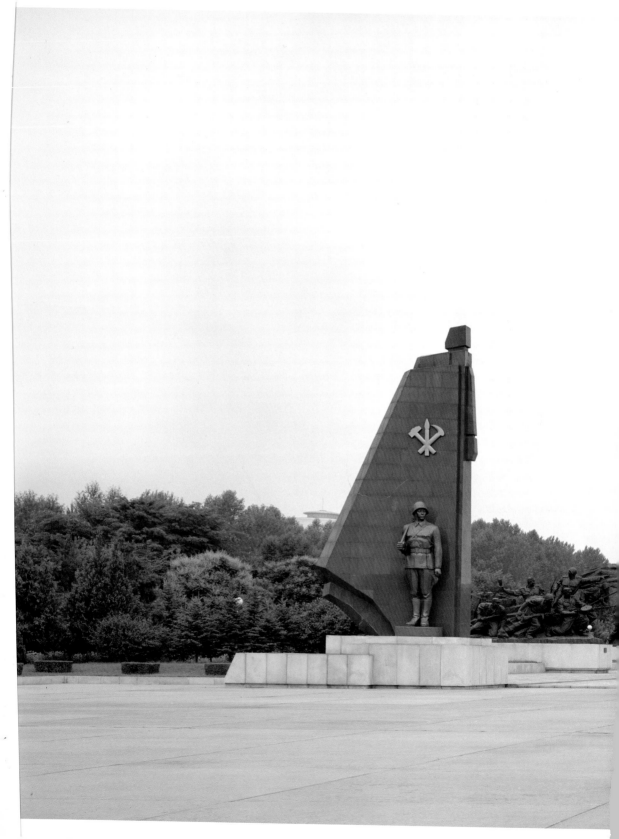

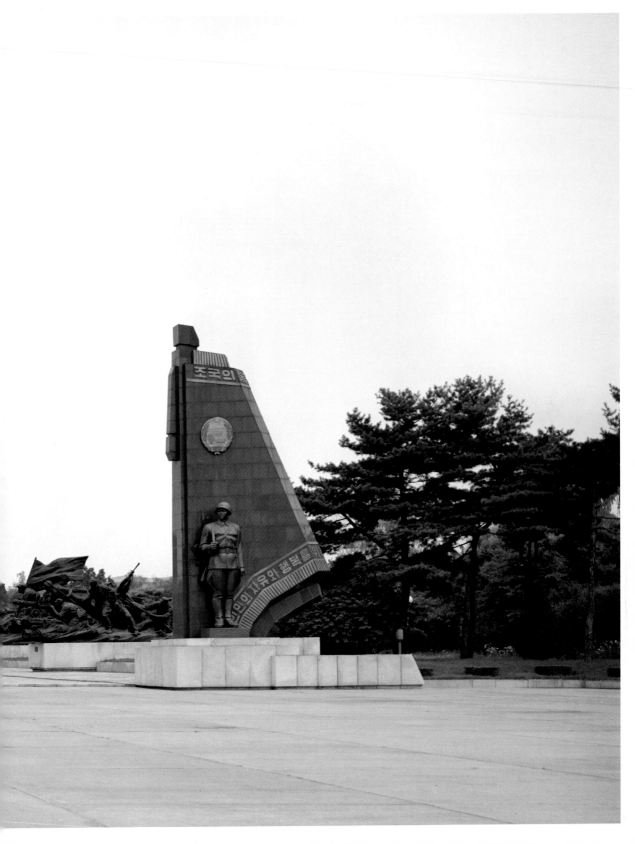

previous pages

Victorious Fatherland Liberation War Monument

On the banks of the Pothong River behind the Victorious Fatherland Liberation War Museum we erected several statues to commemorate the comrades who gave their youth and life to defend the homeland from the US aggressors. This statue park is a good place for people to come and reflect on the exploits of our fighters at that time. On special anniversaries, groups of veterans get together here for reunions and to pay respects to their comrades who are not lucky enough to be here with them. The statues are made of bronze. In the background you can see the Victory sculpture which is a soldier shouting 'Hurray' at the top of his voice.

opposite

Victorious Fatherland Liberation War Museum

The Victorious Fatherland Liberation War is the name we Koreans give to the conflict that Westerners call the Korean War. It is a very important period in our country's history and in world events as it showed that with strong leadership and unbending will even a small country like ours can resist attack by powerful nations such as the United States. Although all the buildings and infrastructure in the DPRK were destroyed in the war, our people survived to build a new independent country. We are extremely proud of all our people who took part in the war effort and all Koreans are taught never to forget the sacrifices that were made for us, and to be vigilant against our enemy's attacks. The guide will lead you around the many halls which show the history of American interference in Korean affairs leading up to the US invasion of Korea in 1950.

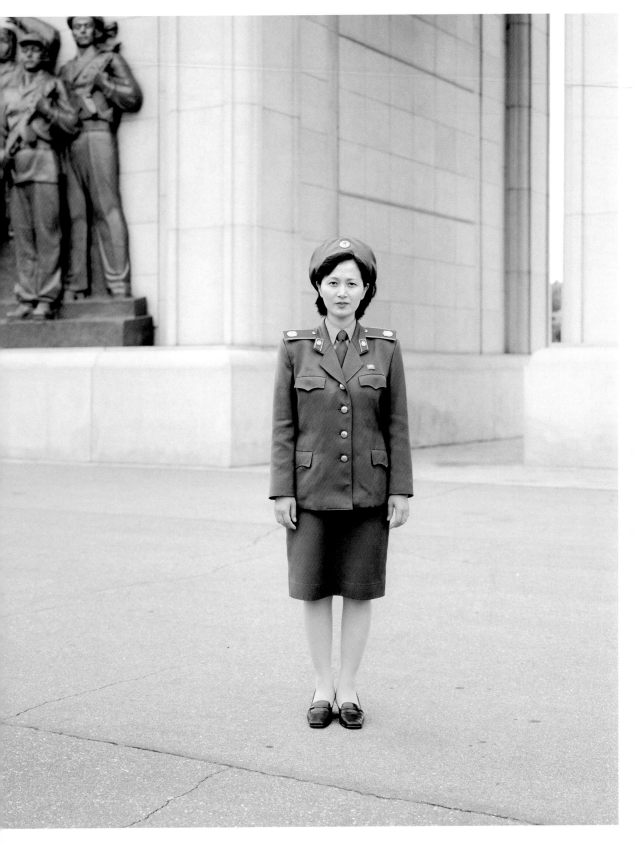

Victorious Fatherland Liberation War Museum

This is Rehearsal Aircraft No. 03 Yak-18 in which the Great Leader Comrade Kim Il Sung personally sat to give advice to trainee pilots when he visited an air force unit on the 26th August 1949. The Museum is actually built around the captured tanks, planes and artillery of the aggressors and it is an important place to visit if you want to understand recent Korean history. My grandparents were killed in the US bombing of our capital in 1951. More than one bomb was dropped for each person in the city and only three buildings in our city were left standing. Pyongyang was totally flattened by bombs and people were burnt by napalm. The US claimed that our country had retuned to the Stone Age and it would not rise again for 100 years.

평양에 온것을 환영합니다.

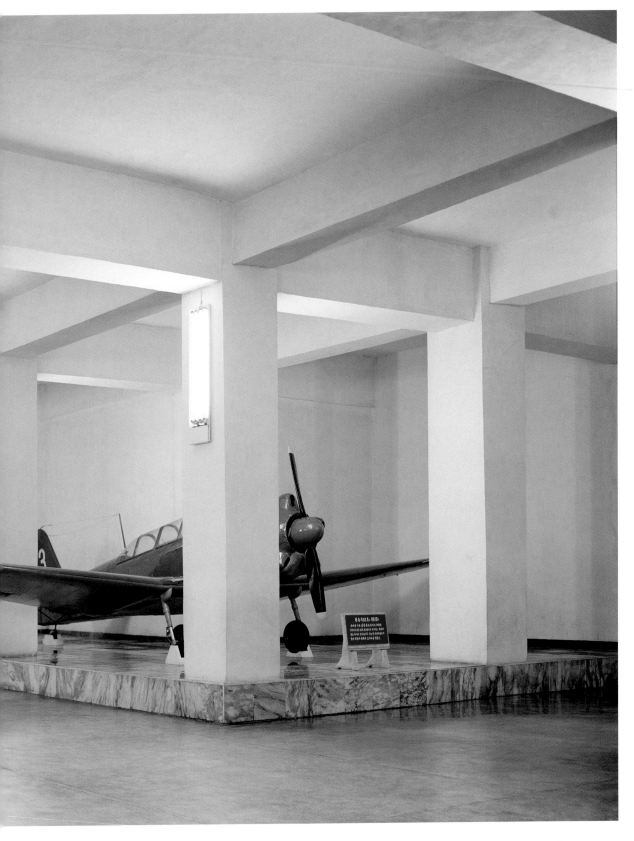

USS Pueblo

On board the USS Pueblo is Captain Kim. He was
in the 1968 sea battle to capture the ship which
was spying on our country. You can see a video
which shows the American sailors who were
captured. One US sailor was killed in the action but
the 82 who were taken prisoner were all released a
year later. You can see the shell holes which were
made by our navy gunners as the Pueblo tried to
outrun us. It is definitely a spy ship and you can
see the spying equipment in the Crypto Room. On
the wall we have framed the apology received from
the US Government.

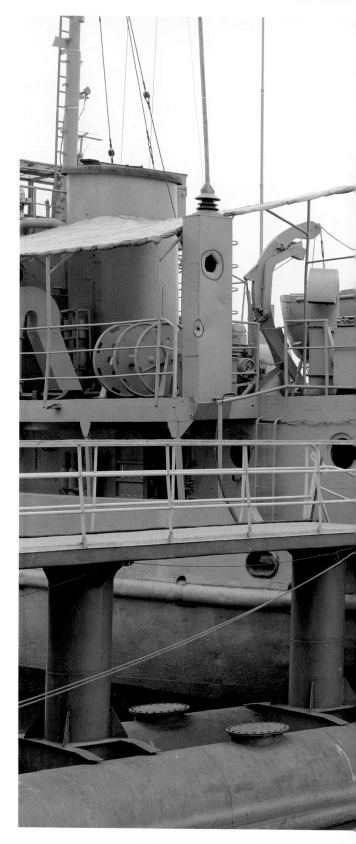

평양에 온 것을 환영합니다.

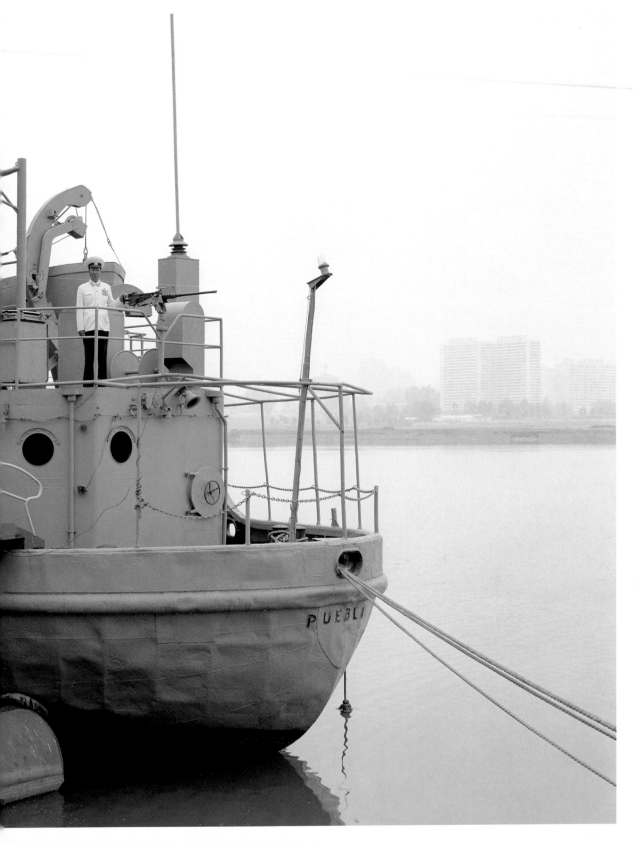

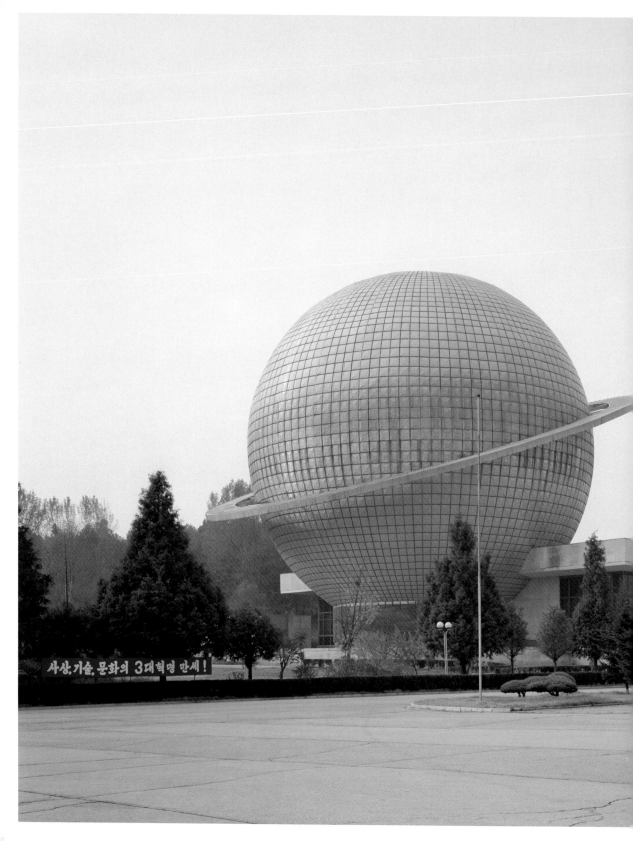

Three Revolutions Exhibition

The Sphere is part of the Electronics Industry Hall at the Three Revolutions Exhibition and it is very recognizable with its unique shape. There is nothing else like it in Pyongyang. It looks like something from outer space. Inside is the planetarium where they turn the lights down and you sit in the dark and can look around you and watch the solar system and see the launch of our space rocket and satellite.

Three Revolutions Exhibition

This is a detector for aiding the taking off and the landing of aeroplanes. There are many pieces of electronic equipment like this in the Three Revolutions Exhibition. We all study electronics at school. I find it a very difficult subject to understand but it is interesting. If you are a pilot then it must be very useful. It is often misty in the mornings in Pyongyang.

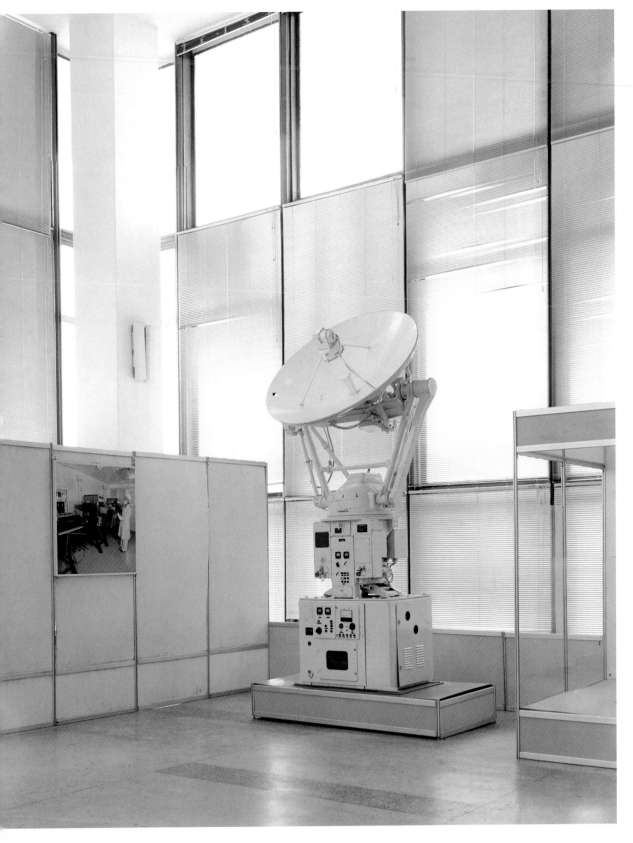

Three Revolutions Exhibition

This is a coupling bolt for a lathe. It is an invention by one of our ingenious engineers. It is displayed at the Three Revolutions Exhibition and perhaps it will inspire workers and students who come on visits here. It may not be the most exciting exhibit in Pyongyang, but it is important for the continuing industrialization of our country.

볼 나사쌍 Ø32×6

수자식조종선반 구성104호의 보내기나사로 쓴다

구성공작기계공장

Three Revolutions Exhibition

The two-storey Heavy Industry Hall is divided
in half – one half for the achievements of heavy
industry and the other half to demonstrate the
strengths of our independent national economy in
power, mining, shipbuilding and transport. There
are some wonderful models which are replicas
of real life. Everyone's favourite is the model
of the floating dock with all the boats moving
electronically. You can see all sorts of mining
equipment that we make and examples of all
types of coal and magnesium. Our country was
oppressed by the Japanese occupation and by the
Americans, but we have developed our industry
to be independent by following the principles of
Juche.

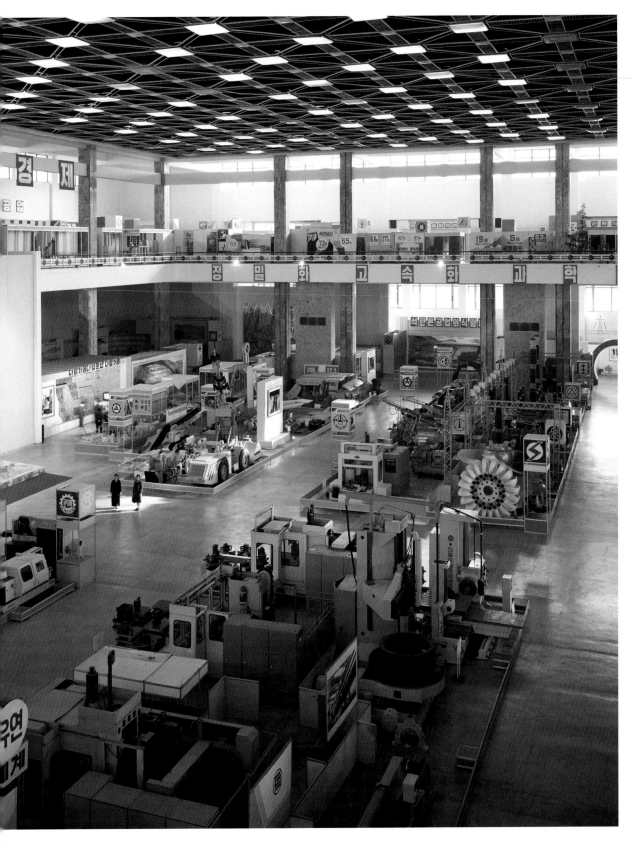

Three Revolutions Exhibition

All the parts of this electronically controlled
hydraulic excavator are made in my country.
Yong Ran works here at the Three Revolutions
Exhibition which demonstrates the advances of
our country in the fields of ideology, technology
and culture. As our country is 80 percent
mountainous, it is strong machinery is important
to help the people in construction and agricultural
projects. Mrs Yong says she cannot actually drive
the excavator but she does know what the controls
are for.

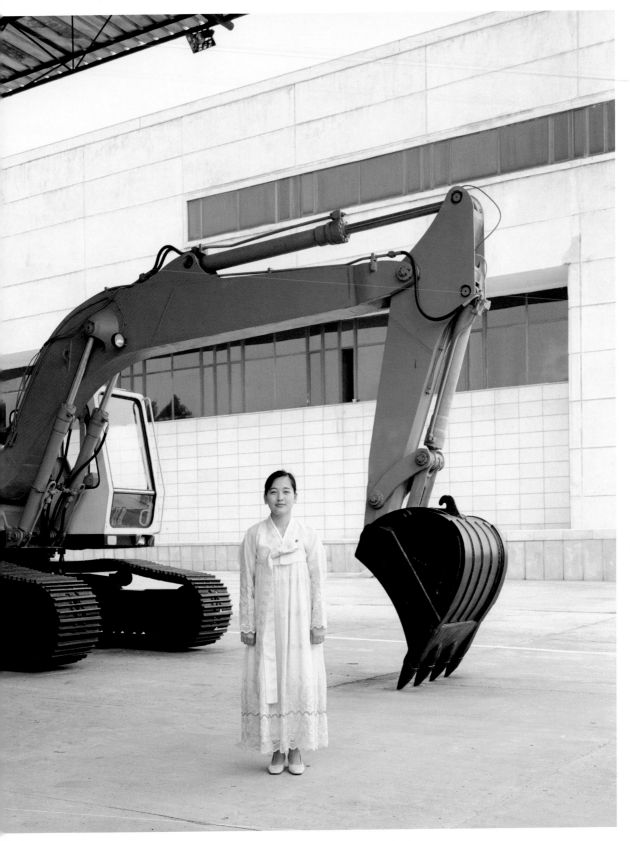

Mangyongdae Petrol Station

This is Miss Pak who works at this brand new petrol station. Miss Pak says she really did not expect to do this type of work after finishing her studies, but her father said it would be a good job. Her responsibility is to fill the vehicles with petrol or diesel in a safe way. She also tells the customers that they must not smoke.

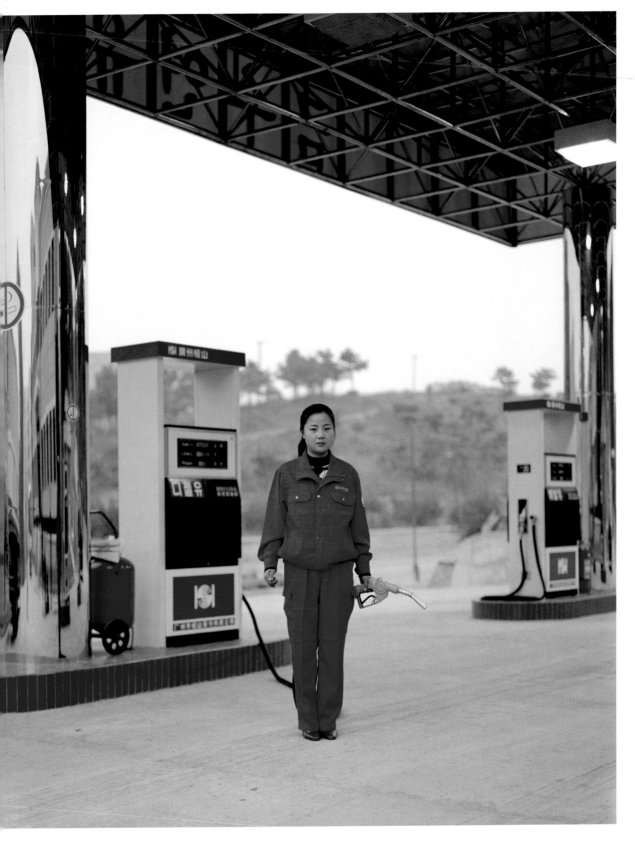

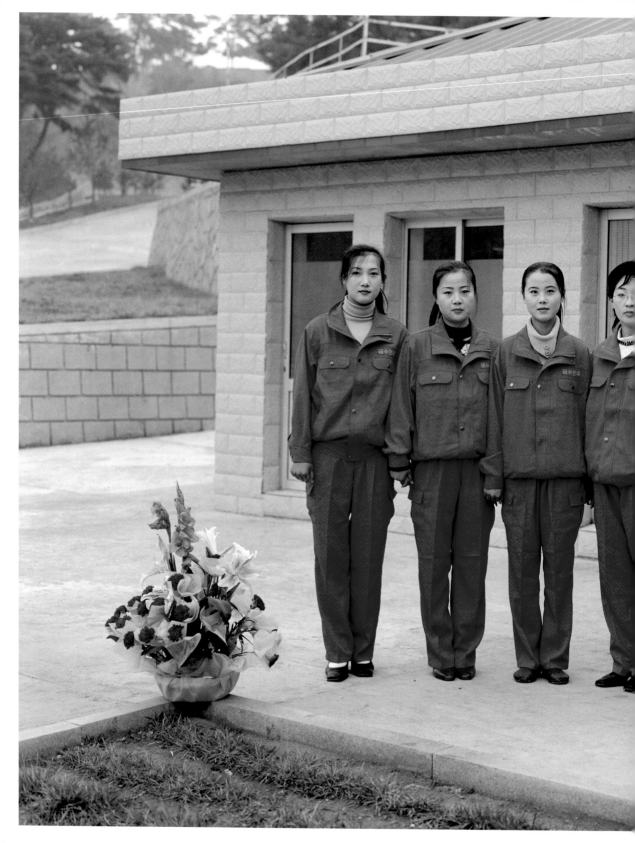

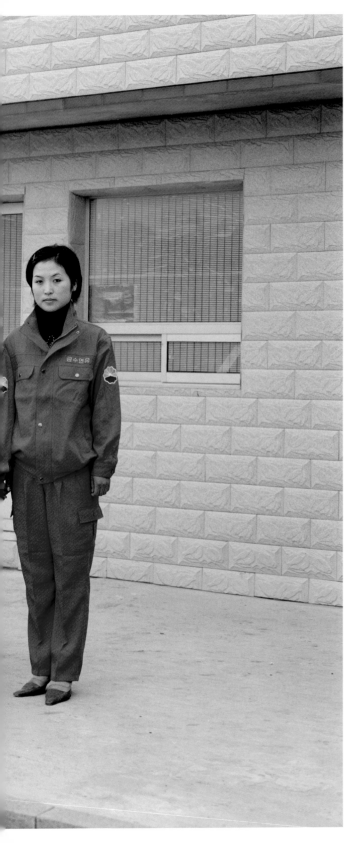

Mangyongdae Petrol Station

Some of these girls have known each other since school but they have all become friends since working at the petrol station. They look like sisters in their overalls. They often go out together after work.

Changgwang Barber Shop

Here is a selection of men's haircuts on offer at the Changgwang Health Complex barber shop. You can of course have your own style but most men my age like to have a sober style. Like anywhere, it is our wives who have the final say! In my country most men like to keep their hair short and we never use dyes or colours, apart from white-haired old people who want to regain their youth. Sometimes they cut the hair of foreigners here but I am not sure if I recommend it unless you want a Korean hair style. Some of the foreign men who come to Pyongyang have very long hair, and I think the barbers here wouldn't know how to cut it. Maybe they would know better at the women's hairdresser next door!

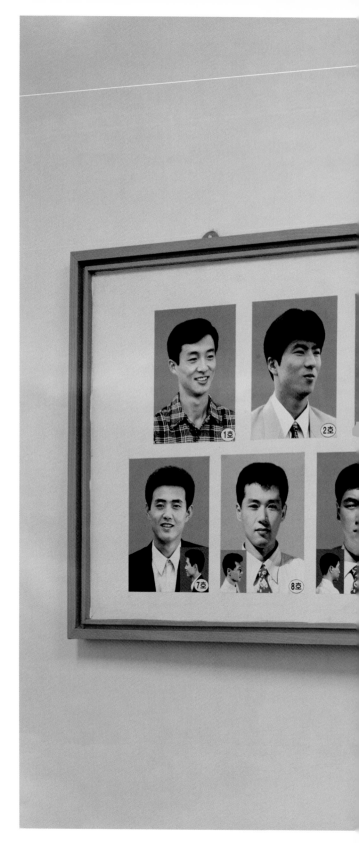

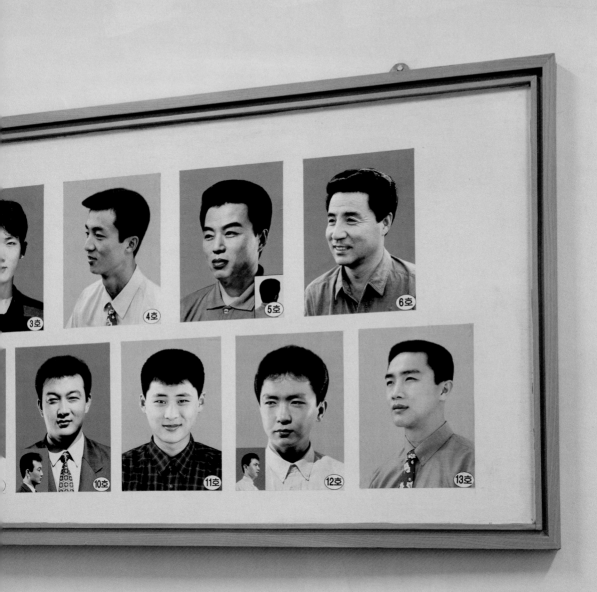

Okryu Cold Noodle Restaurant

Lunch at the Okryu Cold Noodle Restaurant is a big occasion. You will first of all have some summer kimchi, then bean cakes and then some bulgogi. When you are almost full you have the best dish to finish, the most famous dish of Pyongyang – cold noodles. They are made from buckwheat, flour and noodle stock. The stock is made out of cow bones and entrails, cooled and sieved, and boiled and seasoned with salt and soybean sauce. We cool it before serving it in a traditional brass bowl, coated with kimchi. The cold noodles have a unique flavour. Our foreign visitors are generally divided on whether they like them or not but we Koreans like nothing better on a warm day. How much vinegar and mustard you want to add is up to you and your taste buds.

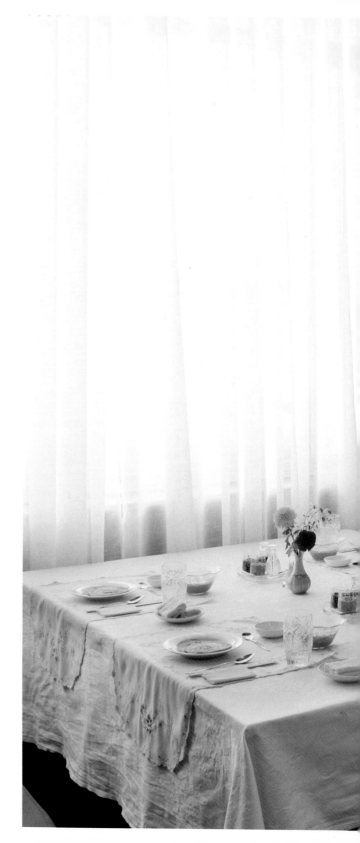

평양에 온것을 환영합니다.

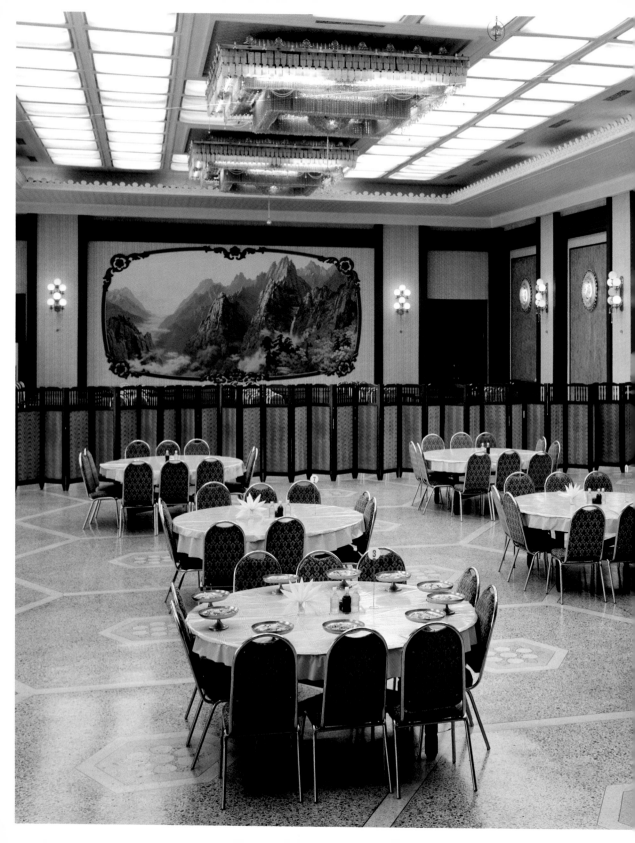

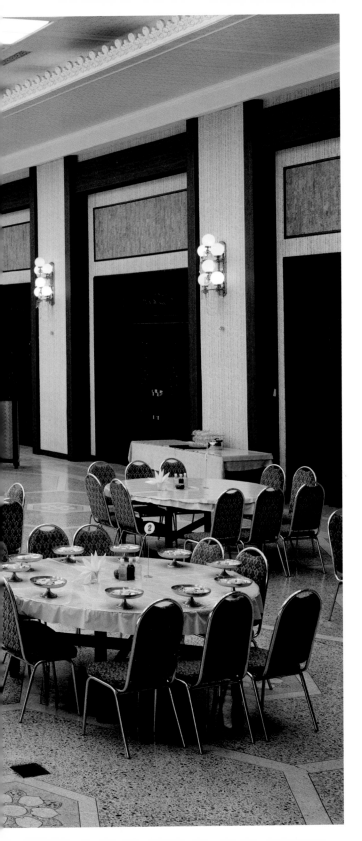

Okryu Cold Noodle Restaurant

Okryu Cold Noodle restaurant is perhaps the most famous restaurant in the whole of DPRK. It was built in August 1960. It really is very good indeed and always full. If you are late you will not get a table. When it is one of our many celebration days, the waitresses are on their feet all day. The restaurant can feed up to 1,500 guests in one session. The architects designed the restaurant to look like a large boat floating on the stream. This room has a mural of the mountains of Kumgang on the wall.

Koryo Hotel

The Koryo Hotel was the first deluxe class hotel built in DPRK and was completed in 1985. The hotel is mainly used by visiting businessmen and delegations and not so many tourists. In the dining room, you can have a Korean breakfast of kimchi, rice and soup. But if that is too spicy or strange to your palette you can choose a western breakfast with fried or scrambled egg or French toast with butter and jam.

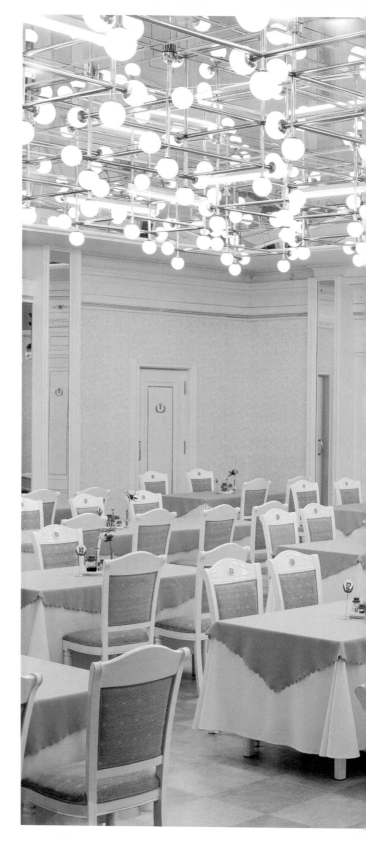

평양에 온것을 환영합니다.

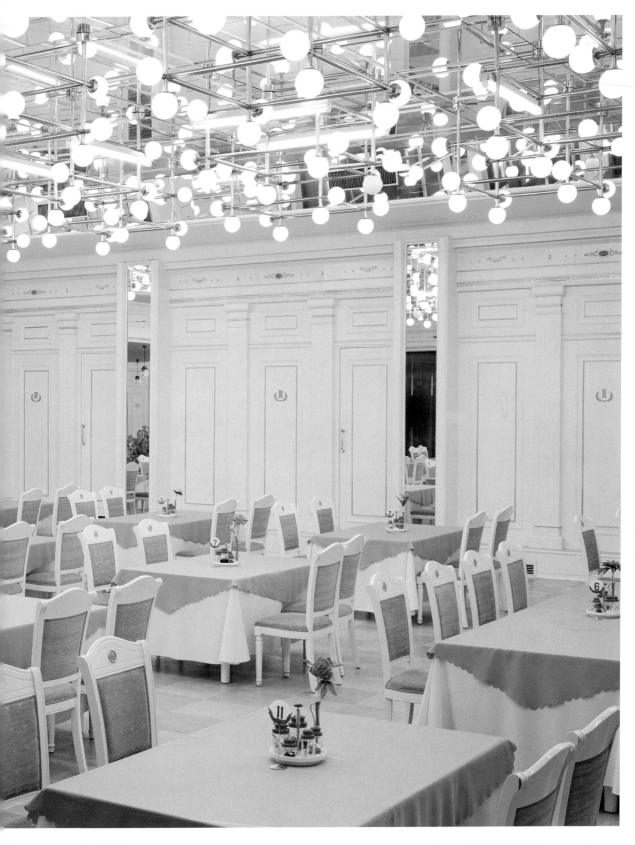

Koryo Hotel

The Koryo Hotel is very distinctive as it has two tall red towers and each one has a revolving restaurant on top. Generally most tourists stay at the Yanggakdo Hotel, but this hotel has a better swimming pool and karaoke room. The Yanggakdo Hotel has bowling and golf, but still I prefer the Koryo as it is the original one and the first deluxe hotel I ever stayed in. The receptionist helps tourists with questions such as how to get a taxi or what time flights depart for Beijing or Vladivostock.

평양에 온것을 환영합니다.

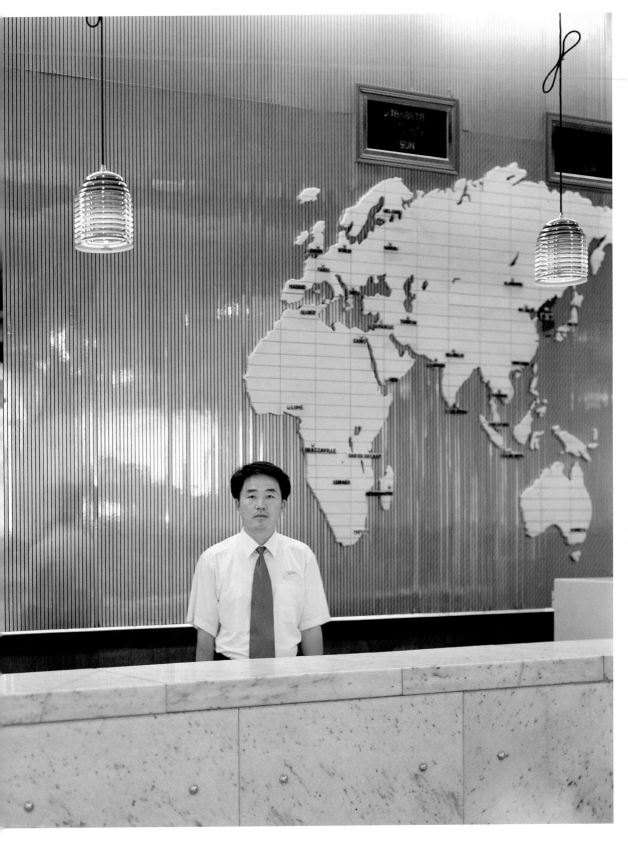

Koryo Hotel

Billiards is one of the most popular games to play in a bar in the DPRK, and so most Pyongyang men are quite good at it. This is Miss Kim. She is 24 and is a waitress in the Koryo Hotel billiards bar. She trained at the Hospitality Training College in Pyongyang and one day she would like to be the manager of the bar. It is very popular in summer with a lot of tourists and visiting businessmen. We Koreans play different versions of billiards to Westerners. My favourite is a version that needs three players rather than two. It is a lot of fun and if you want to play it then you have to visit our country – it is the only place where it is played!

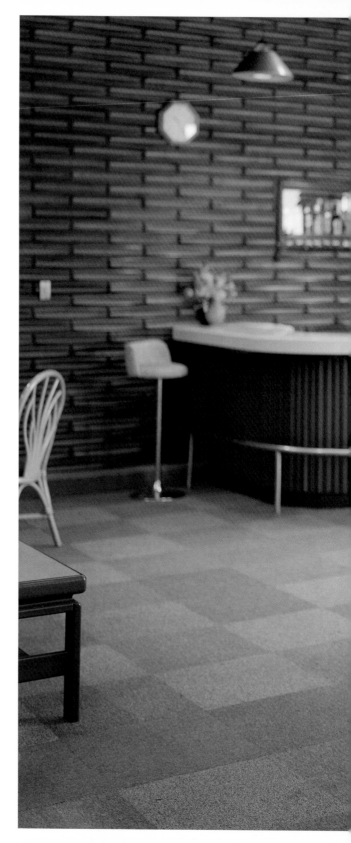

평양에 온것을 환영합니다.

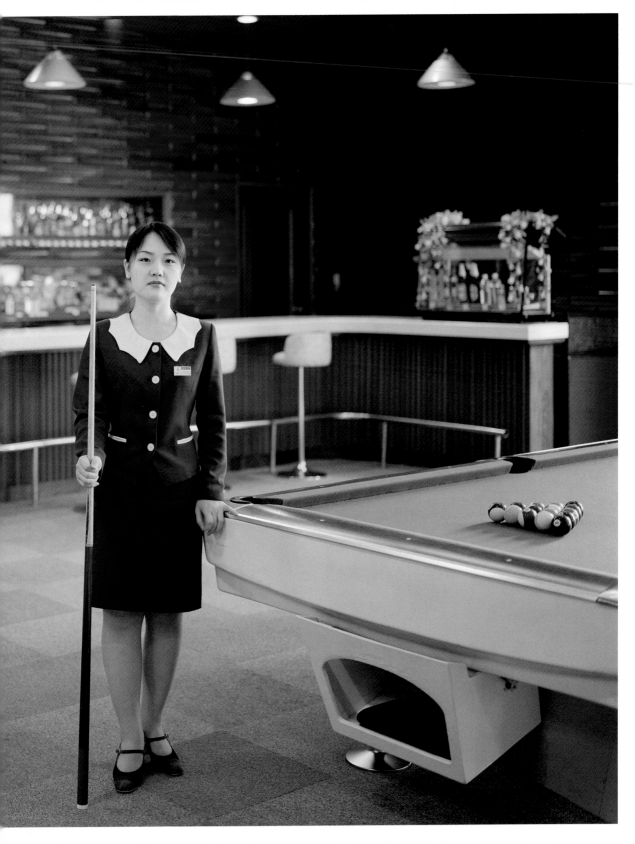

Yanggakdo Hotel

This is the nine-hole Pitch and Putt coffee house and bar at the Yanggakdo Hotel. You can also buy golf equipment here. The caddie is wearing the clothes for slightly cooler weather. In the background is a golf course just like the one on the way to Nampo, which has eighteen holes. We have some Korean golfers and one day we hope they will reach international level.

평양에 온것을 환영합니다.

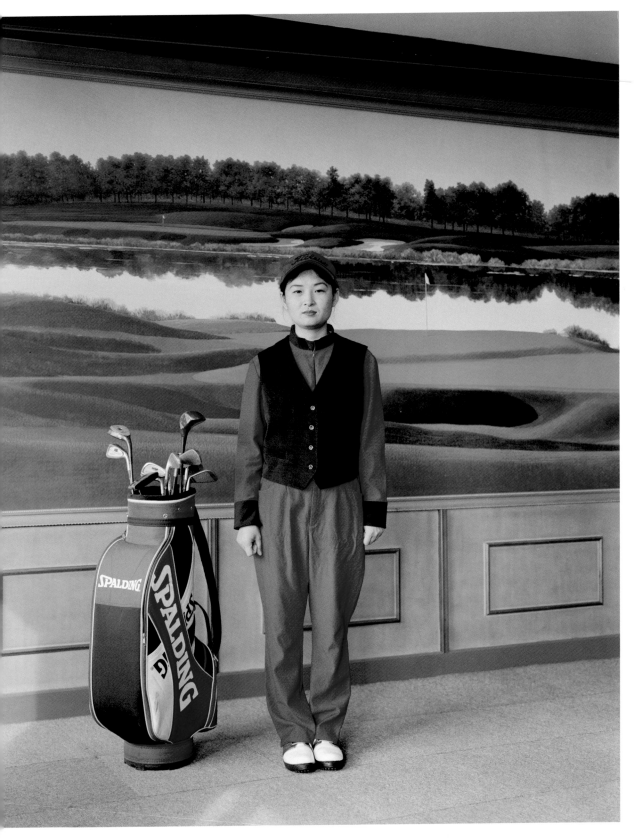

Yanggakdo Hotel

If I was a tourist I would definitely stay at the 1,001 room Yanggakdo Hotel. Although the Koryo Hotel is also a deluxe hotel, I think tourists prefer staying on Yanggakdo Island, where we also have a golf course and tenpin bowling. The bell hop is Mr Cho and he has worked here since the opening of the hotel in 1995. He has been a witness to the increasing number of tourists since this time. Now the majority are Chinese groups, but there are plenty of other international visitors, particularly Europeans. Tips are not a custom in our country.

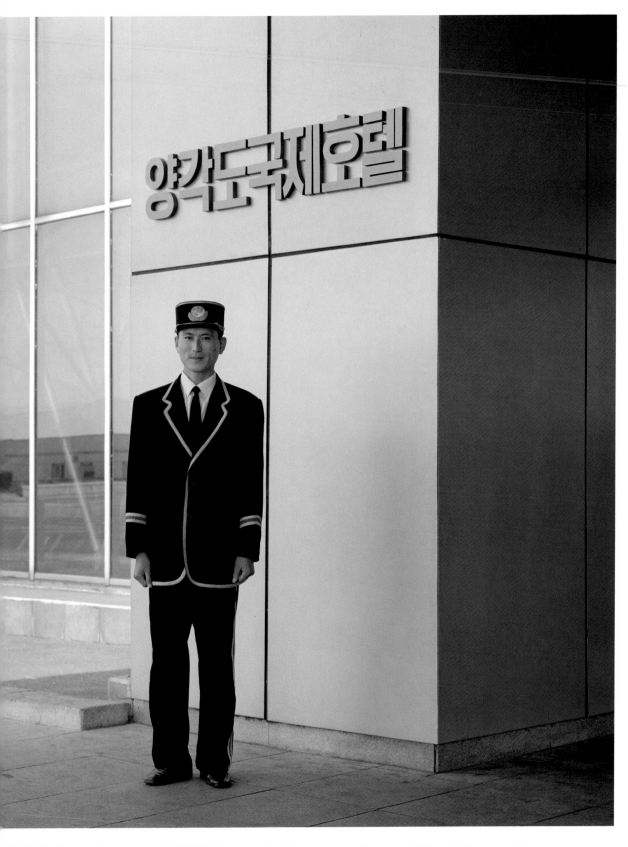

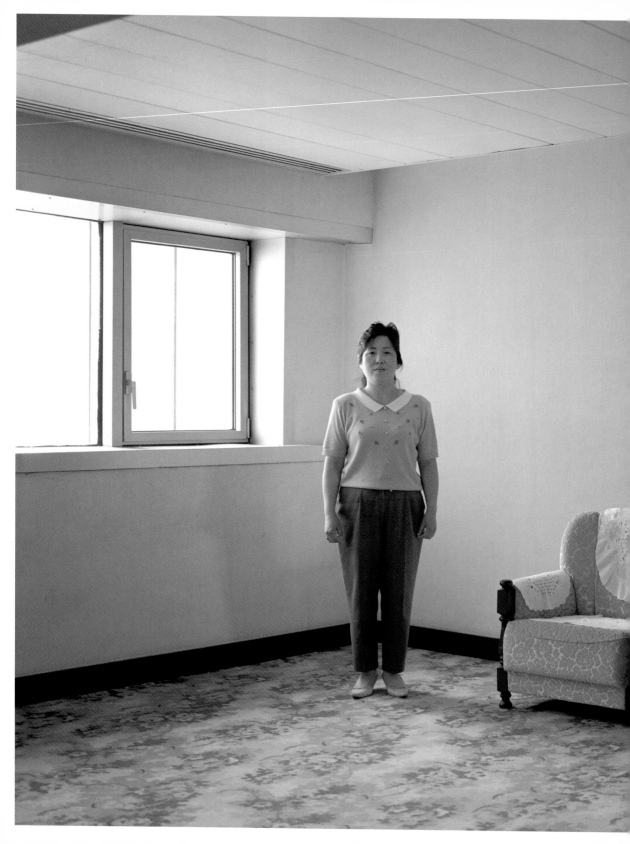

Yanggakdo Hotel

The Yanggakdo Hotel is our second deluxe hotel and one of the tallest buildings in the city. Only the Ryugyong Hotel and the TV tower are taller. It has 47 floors and each one has cleaners dedicated to their specific floor. These ladies are very diligent and make sure that all the rooms always have whatever they need. They take care of laundry and small maintenance work. This is Mrs Hong on the public landing on the 41st floor of the hotel. She is the senior chambermaid on this floor, in charge of 28 rooms. She has been employed here since the hotel opened in 1995 and has great responsibility as the 41st floor is the one where the most important guests stay. Mrs Hong works eight hours a day, five days a week, but she stays at the hotel overnight and is available to deal with any problem that arises, such as if a guest locks themselves out of their room.

Yanggakdo Hotel

This is the public corridor which leads from the hotel lobby to the various private function rooms and restaurants which are booked by foreign delegations when they come to the DPRK. We recently had the Pyongyang International Film Festival in Pyongyang and the delegates were based in the Yanggakdo Hotel and ate in the big private restaurant that this girl works in. This is when I met the actress of our country's new film *Diary of a Schoolgirl*, which is about a schoolgirl who is upset with her absent father while failing to realize he was working hard for the country. And my wife and I went to see *Bride and Prejudice* and *Mr Bean*, while my mother looked after our children.

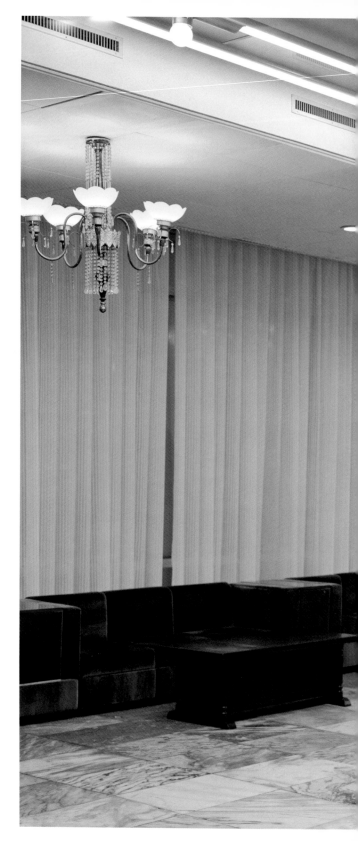

평양에 온것을 환영합니다.

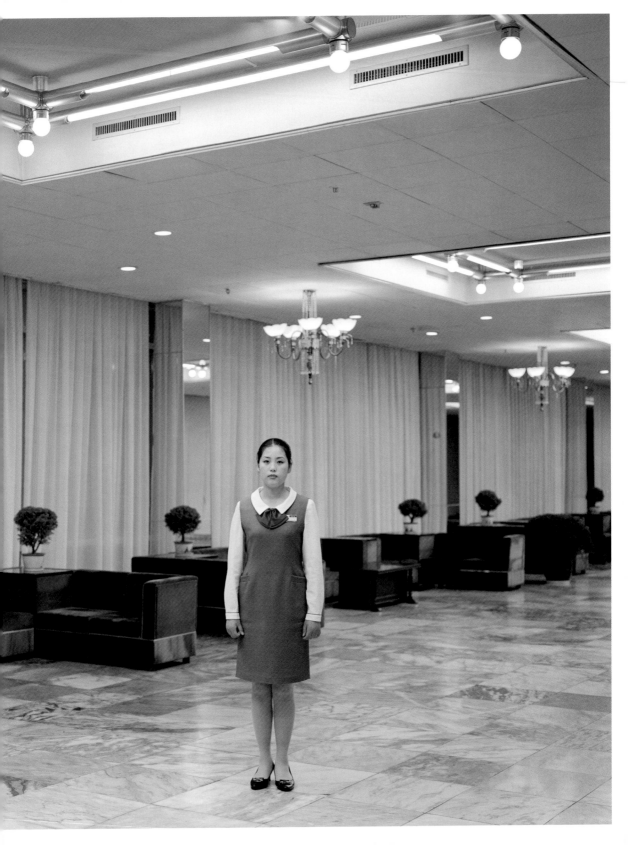

Yanggakdo Hotel

The Lobby of the Yanggakdo is very splendid. High ceilings, shiny floors, new revolving automatic doors and, this year, a refitted bar all make it a good-looking place. I spend a lot of time in the lobby as often the tourists are late in the morning so I have to sit here waiting for them. From the lobby it is possible to change money, make international phone calls and now even to send emails. The internet is something that is not yet widespread in our country. The picture is of Jong Il Peak in the north of our country. This marks the secret camp where Comrade Kim Jong Il was born on 16th February 1942. At that time it was the guerrilla hideout from where we were fighting the Japanese occupation of our country.

평양에 온것을 환영합니다.

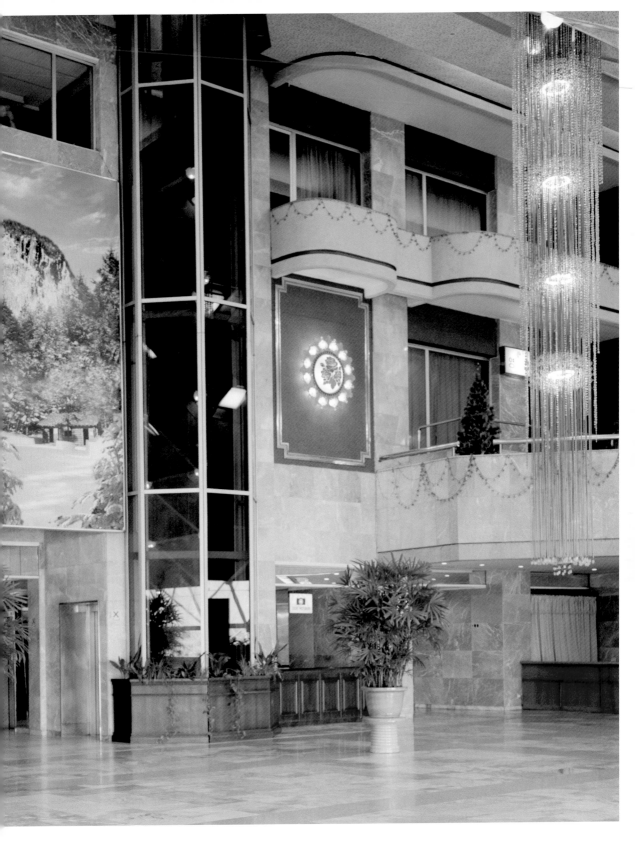

Pyongyang Number One Paddle Boat

Miss Kim is one of the young waitresses on the
Pyongyang Number One Paddle Boat, which goes
up and down the River Taedong. In the high season
tourists will go for a ride on it and have their lunch.
The River Taedong used to be tidal and I remember
my parents saying that Pyongyang occasionally
flooded on a high tide. But since we blocked the
mouth of the river at Nampo with the 8 kilometre
long West Sea Barrage we no longer have floods,
and the water is now freshwater. They say that
Pyongyang women are the most beautiful in Korea.
Miss Kim says she is not beautiful but she looks
alright. She says she is just average.

평양에 온것을 환영합니다.

Korea International Travel Company Guide

This is my friend and colleague Mr Kim, a guide
for the Korea International Travel Company. He is
a very popular guide among the English-speaking
tourists who he works with. Mr Kim has not
travelled abroad yet, but he says that he would
miss the Pyongyang cold noodles and kimchi if he
were away for a long time. He likes guiding tourists
and has met people from around the world. Many
people think it is not possible to visit the DPRK but
we welcome everyone who has a friendly feeling
towards our country.

평양에 온 것을 환영합니다.

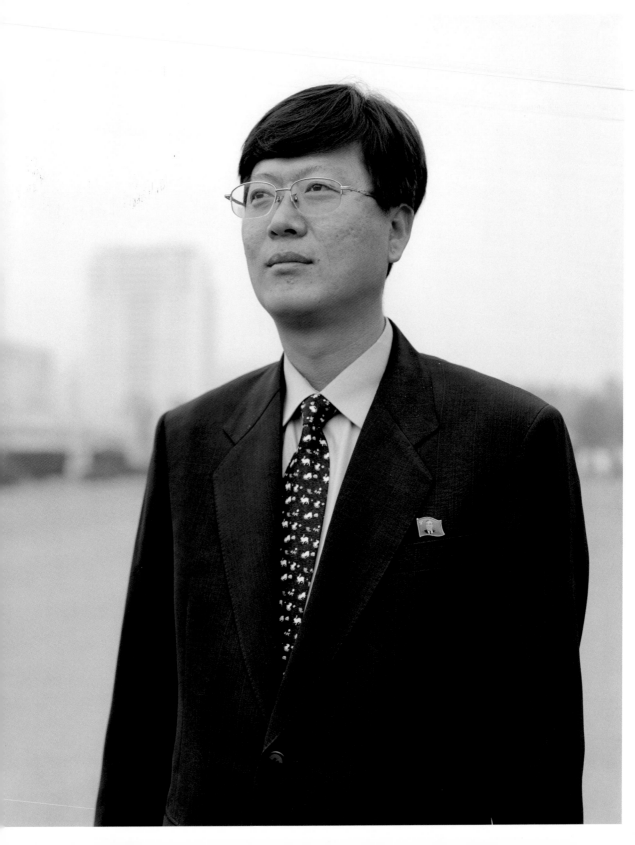

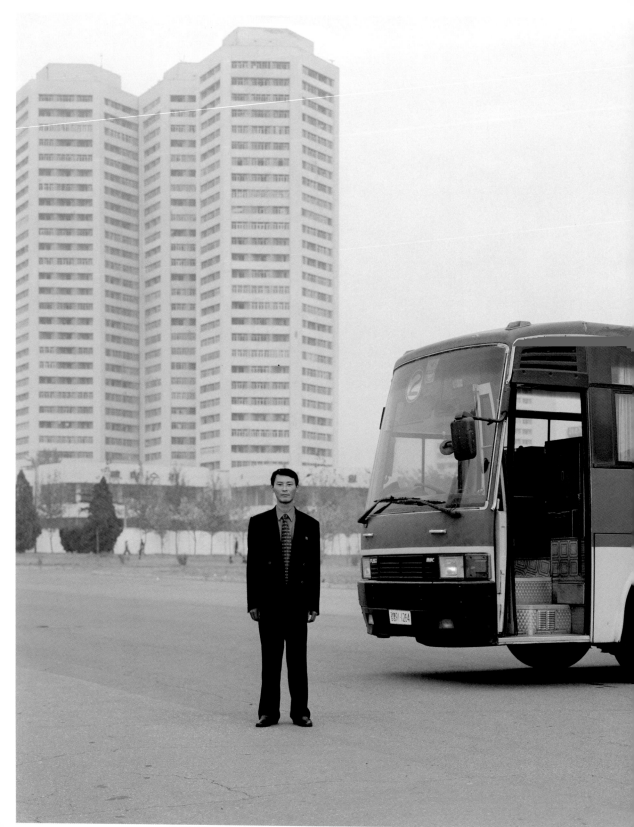

Korea International Travel Company Driver

This is Mr Choe, one of the drivers for the Korea International Travel Company, who is employed to drive tourist groups around while they visit the DPRK. Over the years he has met a great many foreigners and has never once had an accident. He is one of our very best drivers. He learnt to drive while serving in the Korean People's Army. Each driver is assigned a vehicle which is the only one they drive and they are responsible for keeping it clean, safe, well maintained and fuelled so that there is no inconvenience for visitors. When tourists have a long tour around the Friendship Exhibition, he gets a couple of hours to clean the bus and he still has time to have a rest. His favourite destination is the Myohyangsan Mountains.

following pages

Kwangbok Street

'Kwangbok' means Liberation, and this street runs from the centre of the city out to Mangyongdae district. Its construction took only three years and there are over 25,000 modern flats, each between 110 and 180 square metres. It is a good street to live on as the Schoolchildren's Palace is near by and also it is easy to get the trolleybus to work and back. You cannot see many cars on the street because Sunday is declared as a walking day to prevent pollution. Then only cars on urgent business are allowed on the streets. My house is in the Moranbong district and I like to walk to work. It is a 30 minute fast walk to my company each morning and I enjoy the fresh air. I do have a bike but my son is using it to get to university.

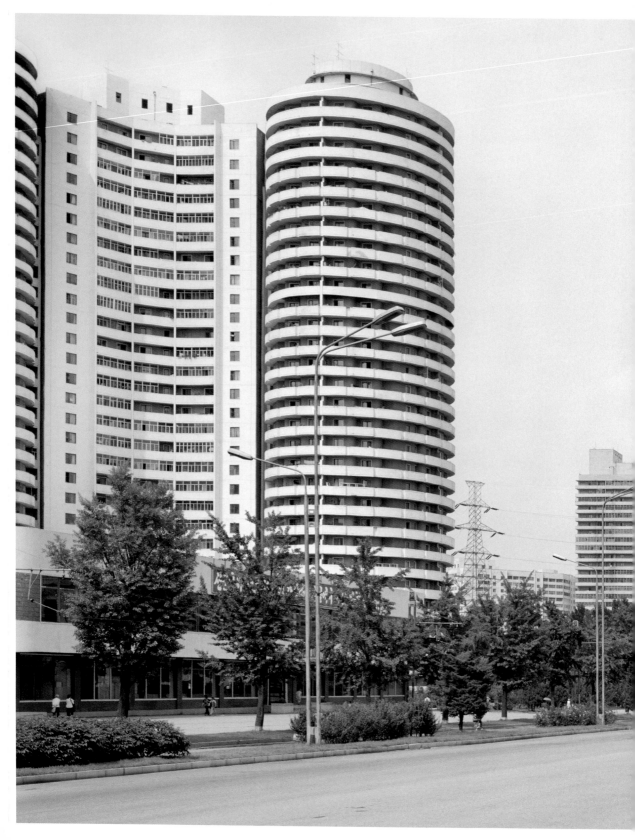

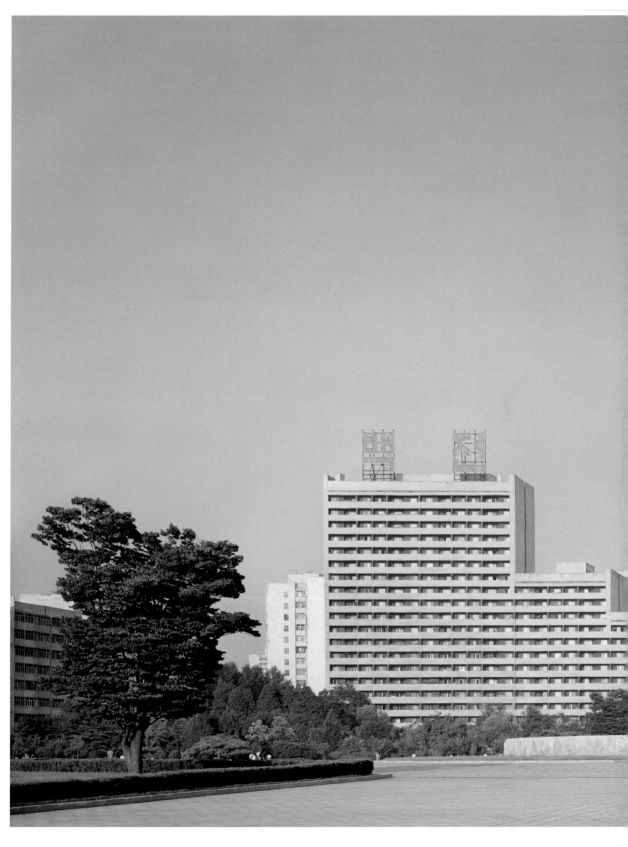

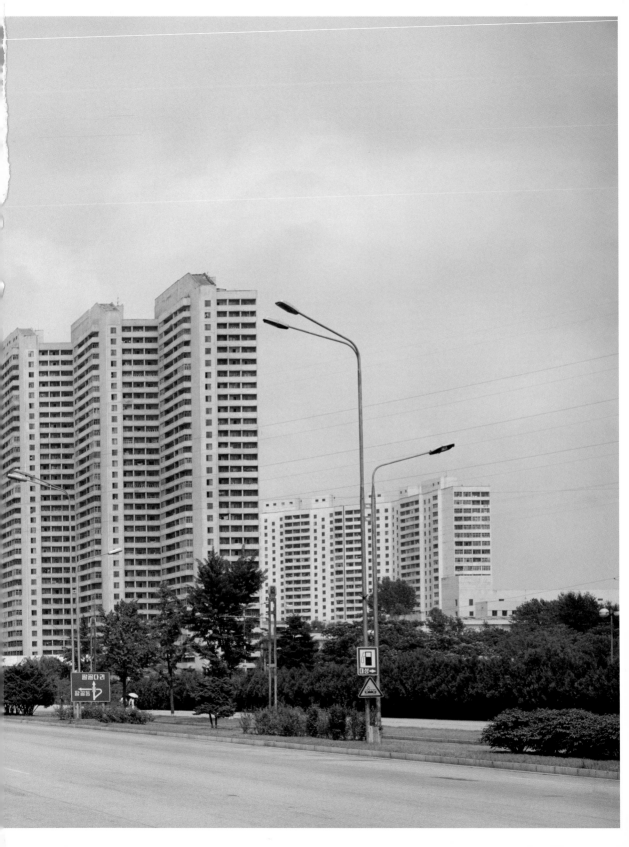

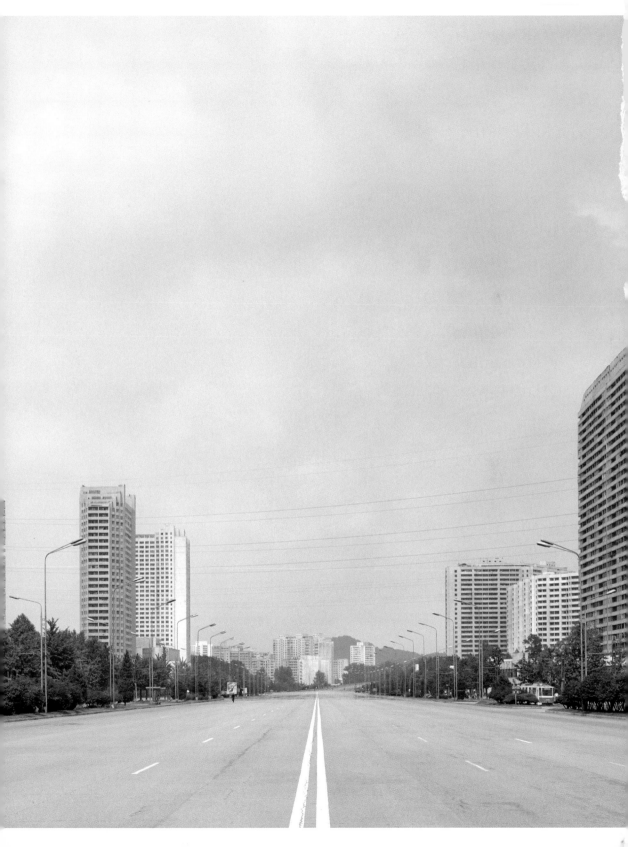

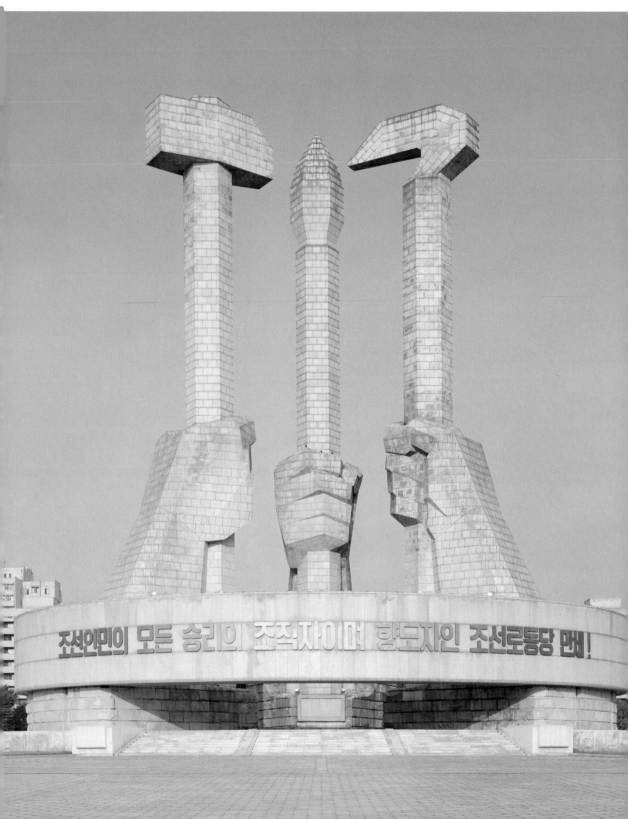

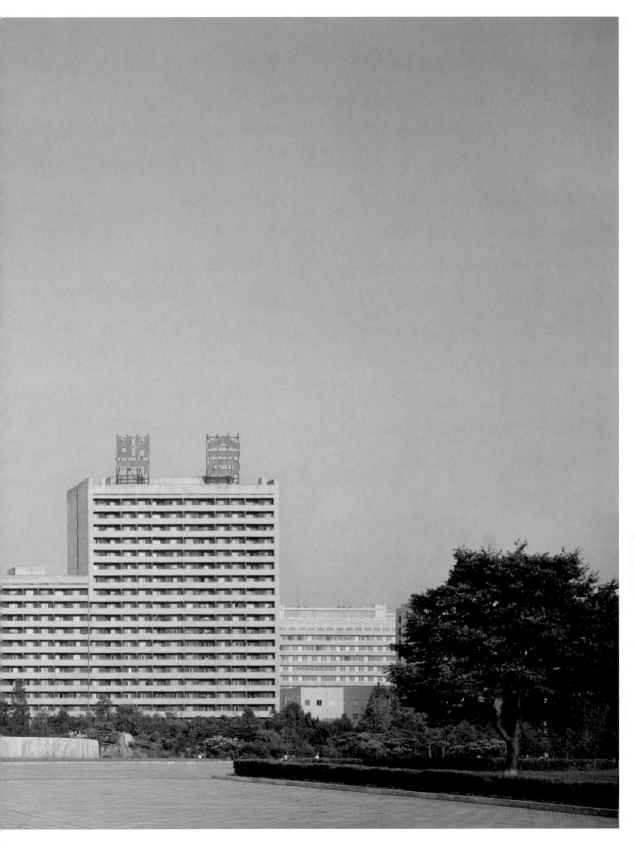

previous pages

Monument to the Party Foundation

This is one of the most distinctive monuments in Pyongyang, called the Monument to the Party Foundation. It was built for the 50th anniversary of the foundation of the Workers' Party of Korea in 1995. You are probably familiar with the emblems of the hammer and sickle, but one of the differences between our revolution and others is that we place equal importance on the role of the intellectual class. This is why we have a third emblem on our party logo – the writing brush which represents the intellectuals. This is just one of the ways in which our system is different from other socialist countries.

opposite

The Korean Revolution Museum

The Korean Revolution Museum shows how the Korean revolution was pioneered and advanced victoriously under the leadership of President Kim Il Sung. This relief shows the revolutionary struggle to free our country from Japanese occupation. The painting above is of the Great Leader with the people celebrating the rebirth of our city. This is the largest of the museums in Pyongyang. It would take you a whole week to look around all the rooms.

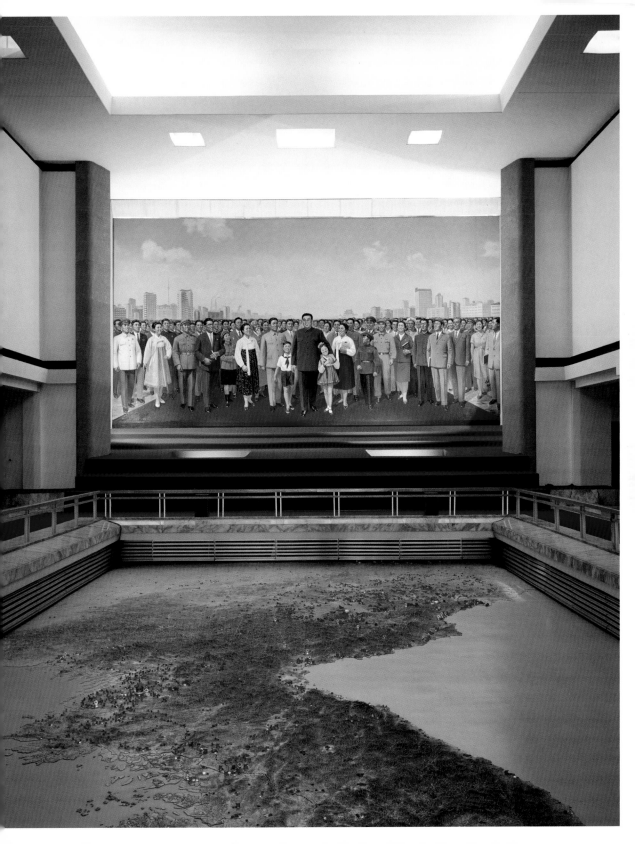

Kimilsungia and Kimjongilia Exhibition Hall

We newly built this exhibition hall especially for the two flowers we hold with the greatest esteem in our country. They were named after our Leaders. The Kimilsungia is a kind of orchid developed by botanists under the direction of President Sukarno of Indonesia, a good friend of our President Kim Il Sung. The Kimjongilia is a breed of orchid created by a Japanese botanist. Each town and county in the DPRK competes to grow the best flowers each year, and this leads to a wonderful exhibition on each of our Leaders' birthdays. My county's national flower is the magnolia but we also favour the azalea too.

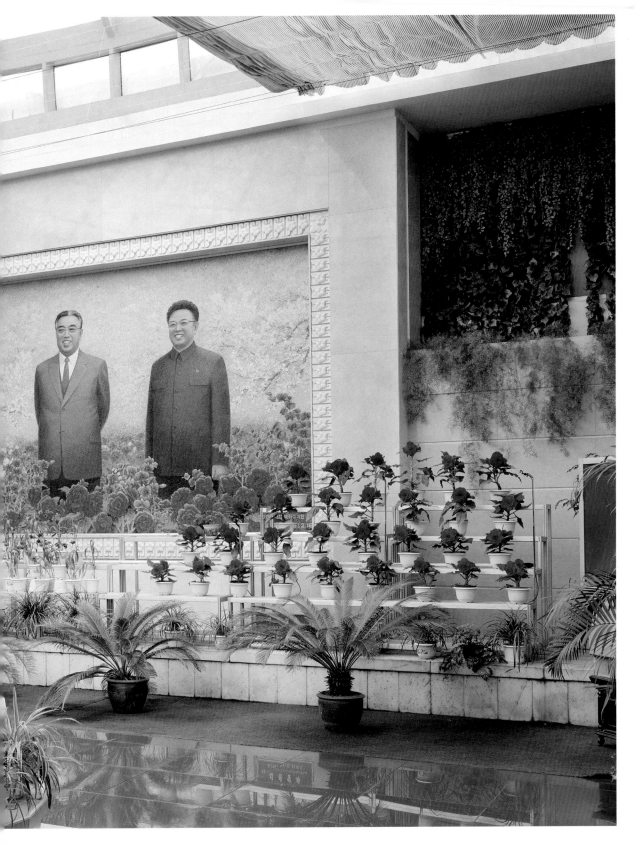

Grand People's Study House

This marble statue of our President Kim Il Sung, seated in front of a view of Mount Paekdu – the sublime mountain of the Korean Revolution – is in the visitors' entrance of the Grand People's Study House. The President advised the construction of this building to help our people educate themselves and improve the nation as a whole, especially those who had missed out on education during the Japanese colonial period and the war years. It was completed in 1972 to mark the 60th birthday of the President and we are very grateful to him for this place as it is probably the best library in the world. It has 30 million books and has helped the education of so many of our people. We have almost 100 percent literacy which we are very proud of, and many people like to read as much as possible.

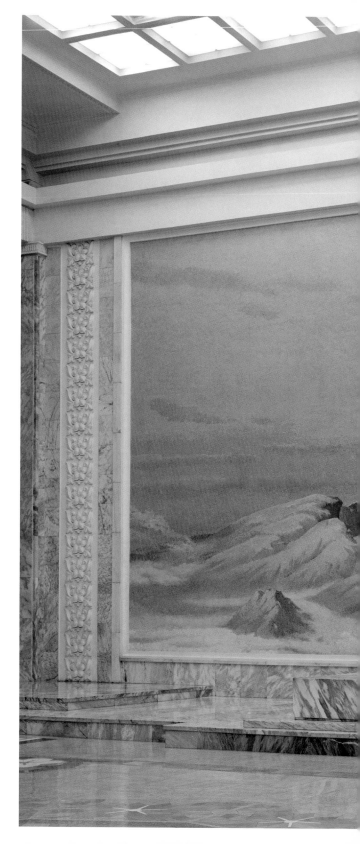

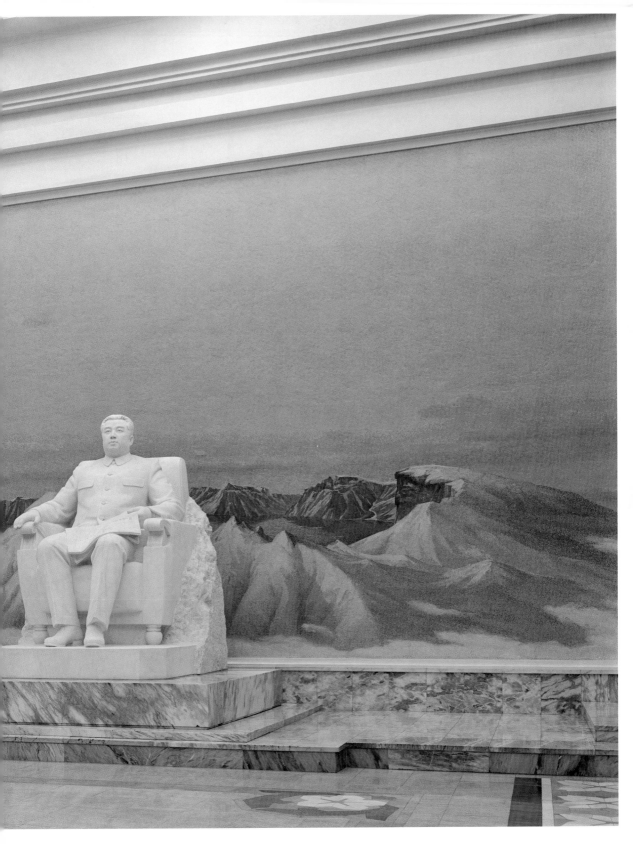

Grand People's Study House

This is one of the reading rooms in the Grand People's Study House and the guide is Mrs He. The Great Leader Kim Il Sung designed the desks for the people so that they are tilted, to aid the reader. He fought tirelessly for the greater good of our Korean people. The Study House has more than 600 rooms for study. We have lecture rooms, recording rooms and consultation rooms where people can speak with experts on certain subjects. The Study House can accommodate over 12,000 people every day. The portraits of our Leaders are held in the highest respect, both at home and work.

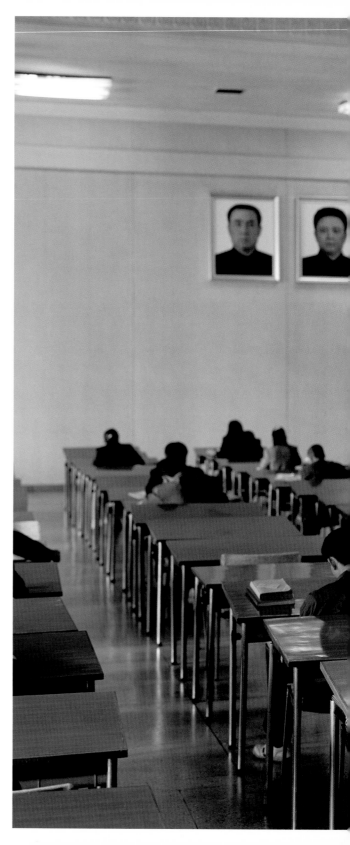

평양에 온것을 환영합니다.

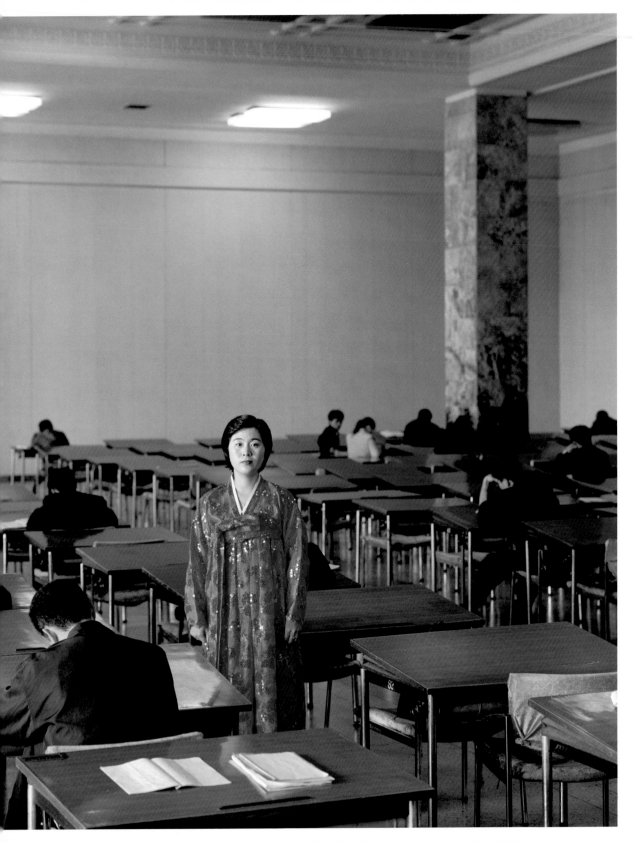

Party Founding Museum

President Kim Il Sung declared the foundation
of the Workers' Party of Korea in this room on
10th October 1945. The Party continues to
lead our country and revolution to this day. The
photographic portrait is of our President from
this time, and there are also pictures to the side
of Lenin, Stalin, Marx and Engels. Here you can
listen to a recording of the broadcast of our late
President's radio speech for the New Year of 1947.
To hear his actual voice is very moving. The slogan
behind says 'Workers of the World Unite'.

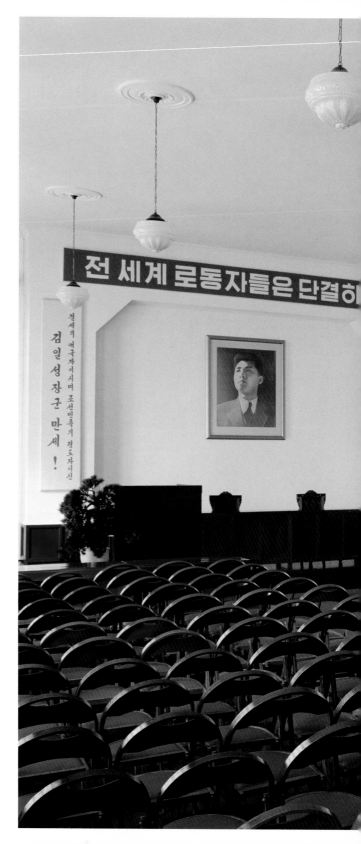

평양에 온것을 환영합니다.

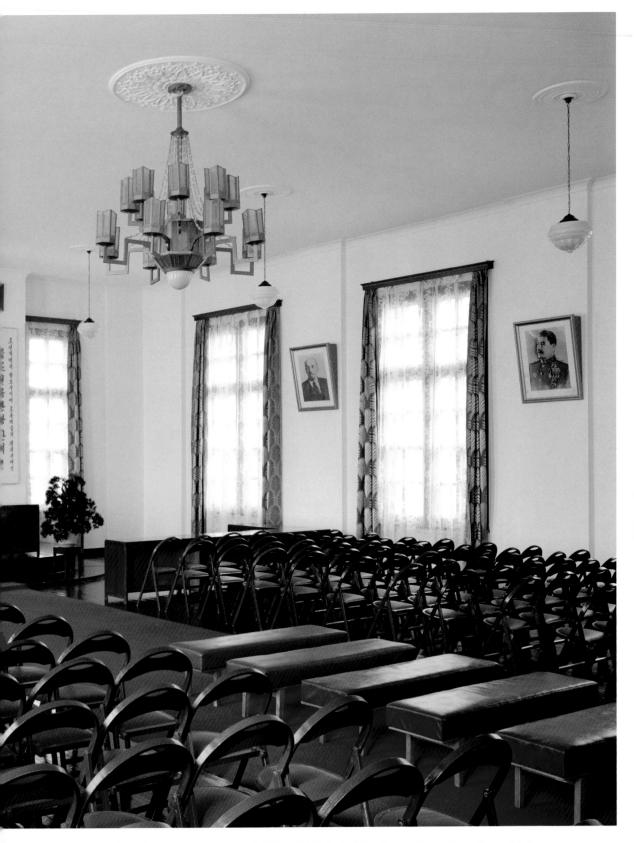

Party Founding Museum

This is the desk that our President worked at for many years. Immediately after liberation from Japan this building was used as his office, and it is one of only three buildings in Pyongyang that survived the American bombardment during the Fatherland Liberation War. It is the very desk where our President created many of the fundamental policies that we still follow today and where he wrote many books and papers to show us the correct way to build our society. This is a place of great importance to all the people of our country as so many important decisions were made right here. We are careful never to touch the desk as we don't want to leave any marks.

Kim Il Sung University

This classroom is no longer used for studying, now it is part of the museum at Kim Il Sung University, the best university in our country. This room is where our Dear Leader Kim Jong Il studied when he was a student. His desk is marked with a plaque. He graduated in Politics and Economics.

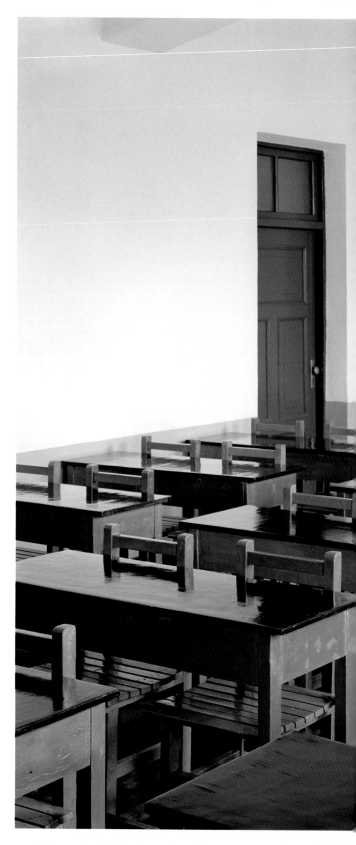

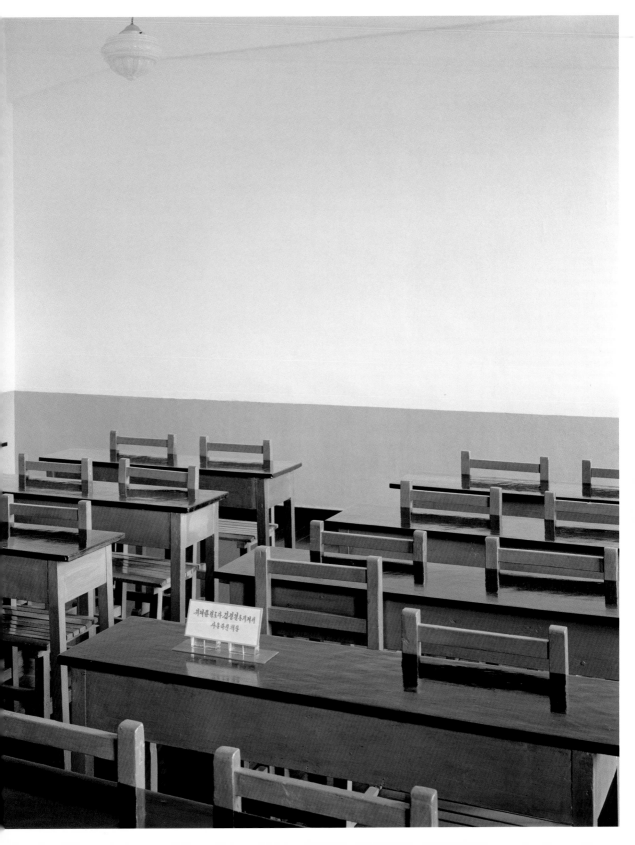

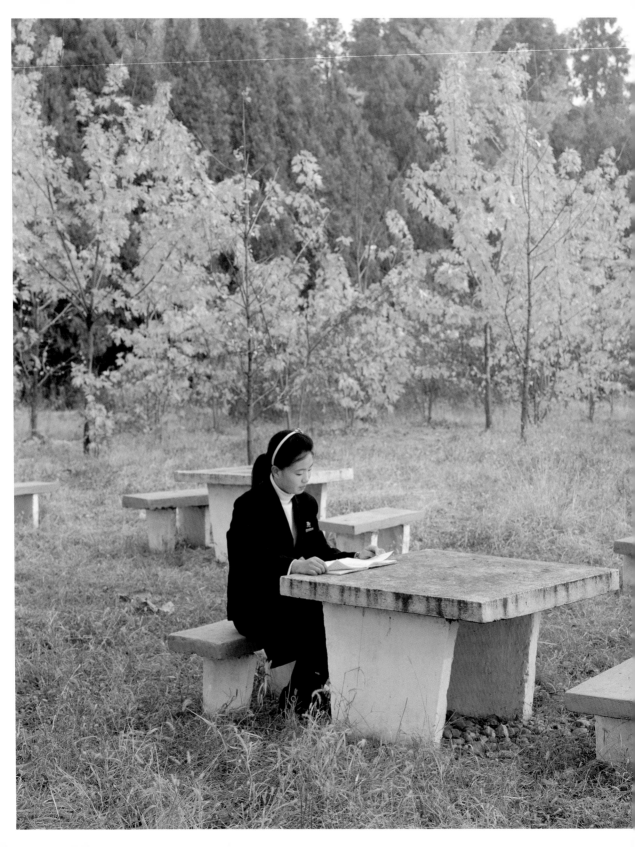

Kim Il Sung University

As everyone knows, we recently held a successful nuclear test explosion and we are very proud of our scientists who are working to build a strong country. Student Jong Hyo Sim is studying at the Atomic Power Faculty of Kim Il Sung University. I went to the University of Foreign Languages and my parents were very proud of my achievements. We come from the countryside, and it was more than they ever hoped for that their son could go to such a prestigious institution.

Kim Il Sung University

Student Gong Hyon U studies at the Computer Faculty at Kim Il Sung University. Young people like studying computers. It is a kind of trend at this time. When he finishes, he is going to join the Korean People's Army. Under the Songun policy, our young people are proud to join the army. They can choose to do this before or after university. Whilst our country is under threat from US imperialism, we have to have our Army First policy. On top of the main building of the university is the slogan 'Great Leader Comrade Kim Il Sung Will Be With Us Forever'.

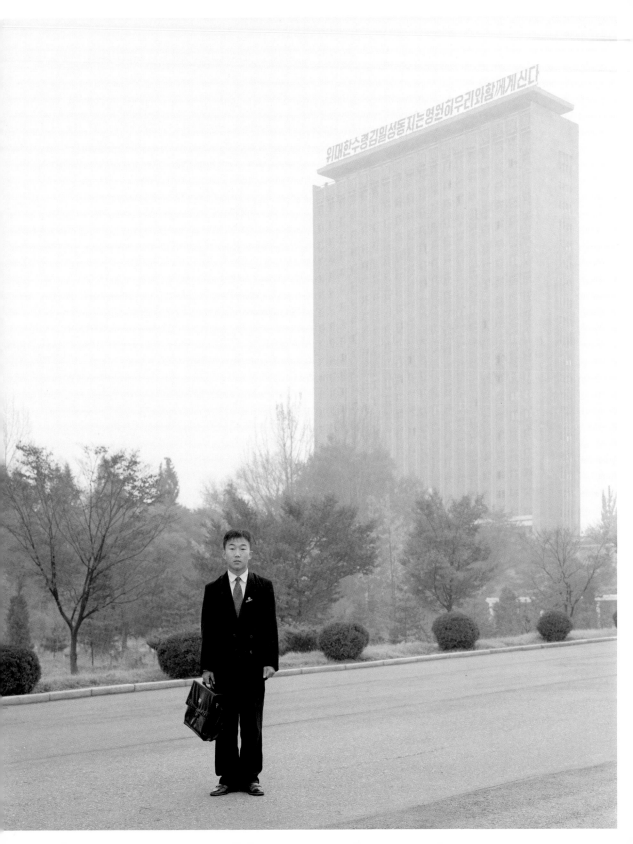

Mangyongdae School Children's Palace

You can tell from Kim Chol's neckerchief that he is a member of the School Children's Union, and because it is red it means he is a model student. The colour signifies the blood of the Revolutionary Martyrs who fought the Japanese occupation of our country, and so every child is very proud of wearing it. How good they have been at school depends on how early they join the Union but it is normally at around nine years of age. Eventually all children get one. Kim Chol is studying the Korean flute at the Mangyongdae School Children's Palace. The Palace is one of the centres for excellence in the arts and the building is shaped in the curve of a mother's embrace.

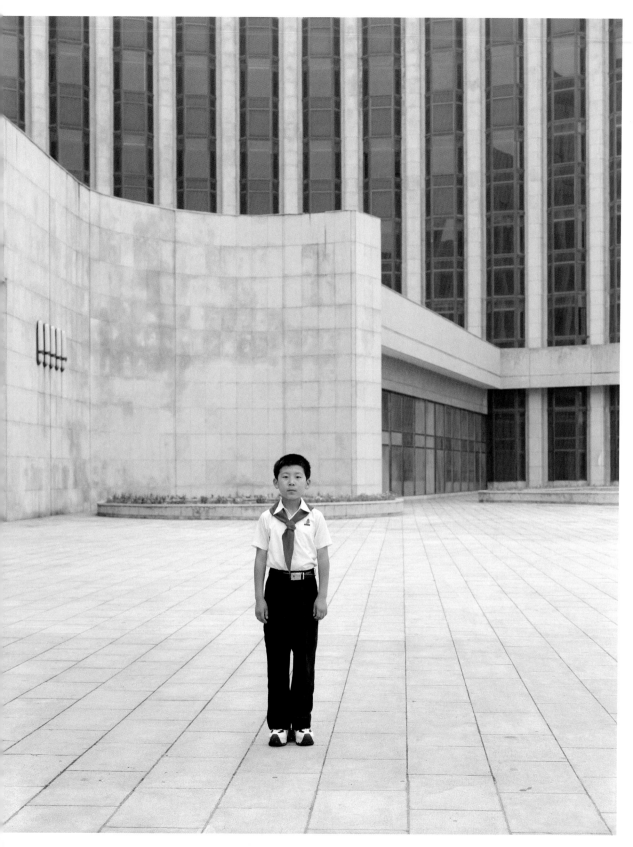

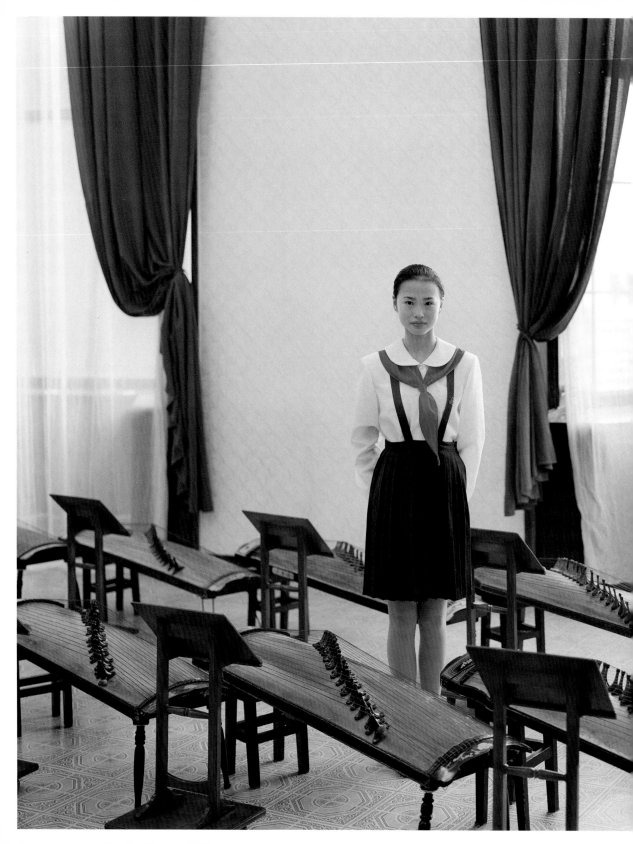

Mangyongdae School Children's Palace

Chae Jong Sim is fourteen years old and goes to Dangsang Secondary School. She studies at the School Children's Palace three times every week from three to six in the afternoon. She has been learning to play the kayagum for four years and would like to teach others how to play it. The kayagum of the DPRK was adapted by our Leader and it differs from the kayagum you find in the south by having 21 strings. We have a folk tale in which the fairies of Mount Kumgang play the instrument. Its sound is of great beauty. We say it is like the human voice.

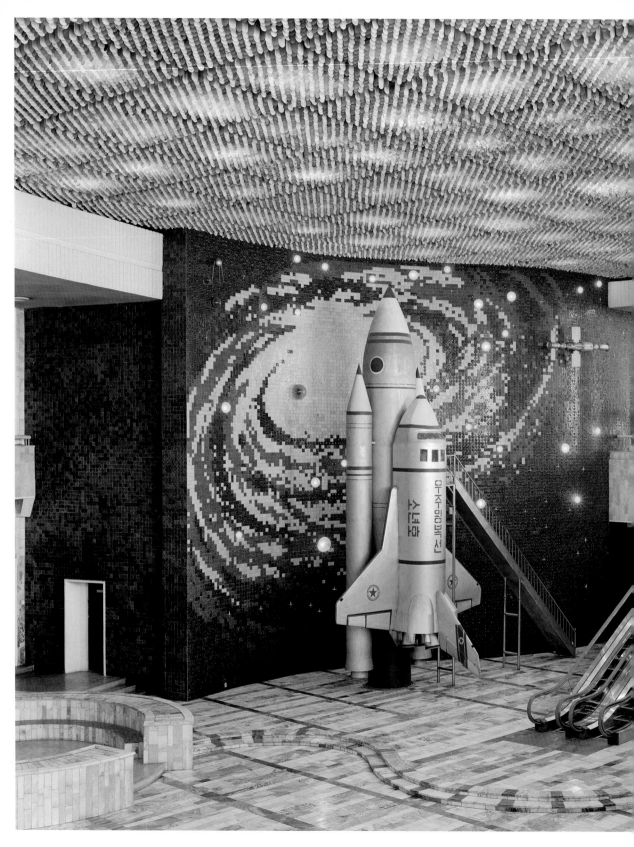

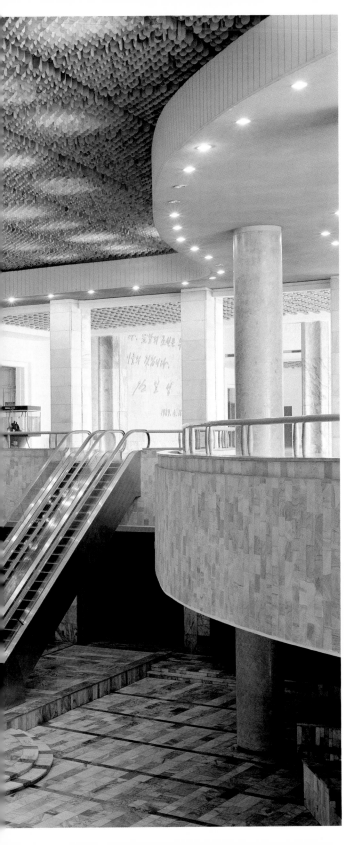

Mangyongdae School Children's Palace

This model of a space shuttle is in the Science Hall of Mangyongdae School Children's Palace. It represents the great leaps in science that our nation made, although we have not built a space shuttle yet. One day we hope to be able to do this. In 1997 we launched our first satellite and we continue to develop peaceful technology such as this for the benefit of all people. The students come into this hall for meetings and scientific seminars.

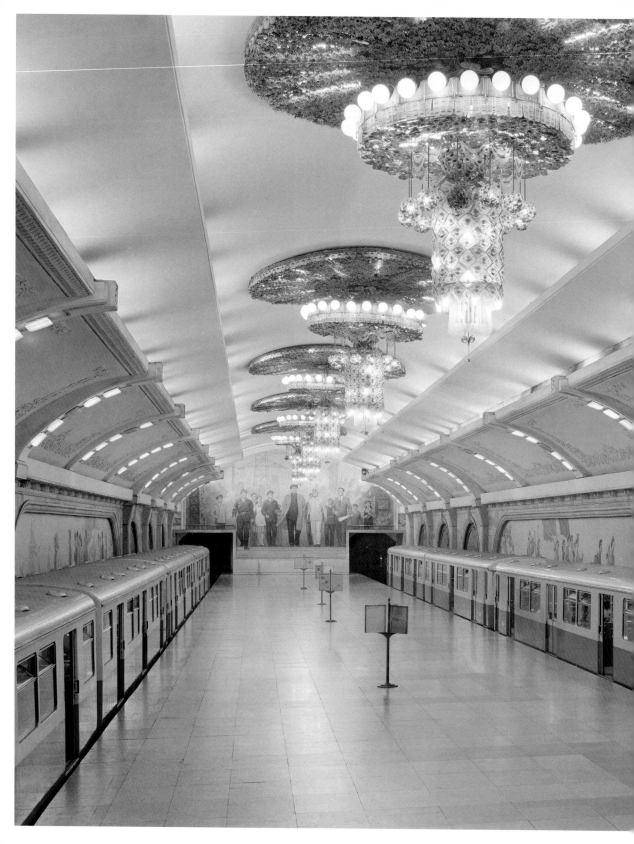

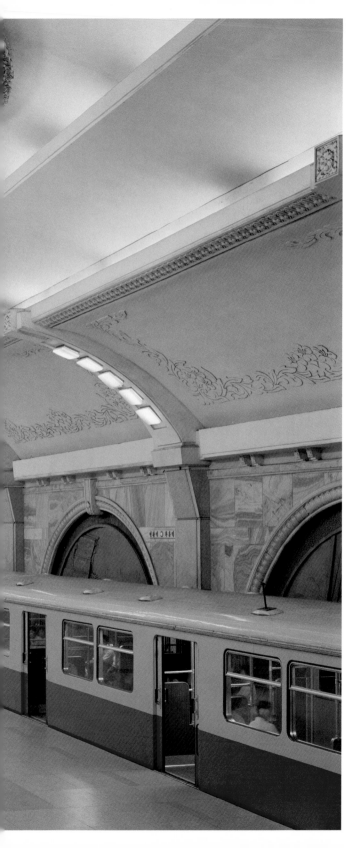

Puhung Metro Station

Many cities in the world have a metro system but ours is special as it is the deepest in the world. It is over 100 metres below the ground. We have two lines in Pyongyang that run all across the city. You just pay for one ticket to go anywhere, and when tour groups visit they don't have to pay at all. The system is very efficient and many people use the metro every day, particularly during rush hours. As you can see we don't have any litter or damage in the metro. The citizens are very proud of the metro and take good care of it. The inside is decorated to convey our revolutionary history – such as the mural at the far end of Puhung Station, which is of our Great Leader Comrade Kim Il Sung among the Workers.

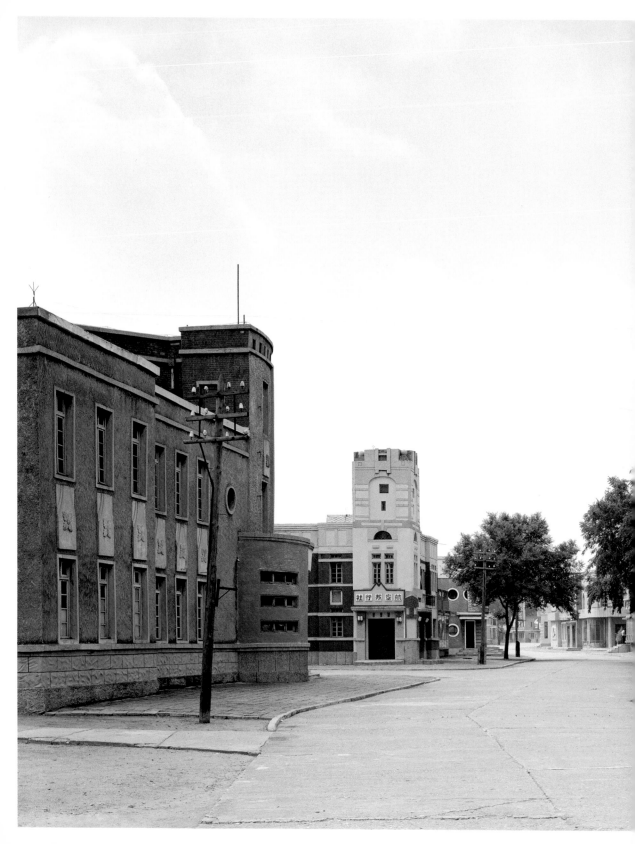

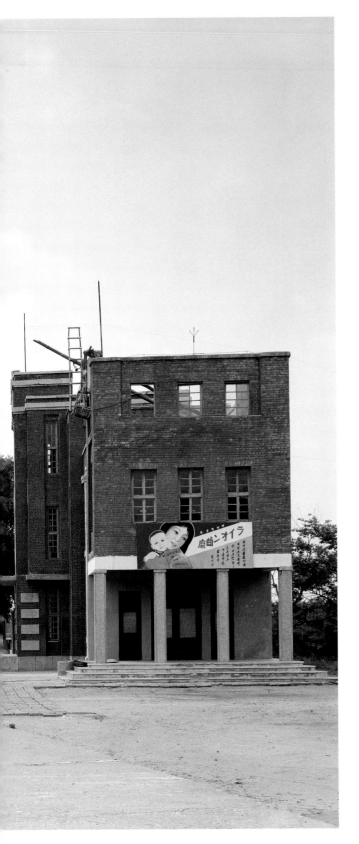

Film Studios

This is the film studio where we have made the film version of the revolutionary opera *The Flower Girl*. We are looking down a street with a Japanese theme, around the time of liberation. In recent years many excellent films have been filmed here thanks to the Dear Comrade Kim Jong Il's wise leadership. Immortal classics such as *The Sea of Blood* are cited as masterpieces of our film art for their revolutionary themes. *The Flower Girl* is also a very popular film in China. Among my favourite excellent films are *Five Guerrilla Brothers* which portrays the anti-Japanese revolutionary fighters, and *The Story of a Nurse* which depicts the heroic exploits of the People's Army in the Fatherland Liberation War. We also have films to inspire the people in their revolutionary struggle for socialist construction, like *The Path to Awakening* and the series *Nation and Destiny*.

평양에 온것을 환영합니다.

The Korean Revolution Museum

The guide of the Korean Revolution Museum is wearing traditional clothing which we still use today for formal occasions and celebrations. Our university students also wear this type of dress. Korean ladies like white clothes, which reflect purity. The guide shows local and foreign visitors around and answers any questions but says she is still learning as there is so much to understand. She studied Revolutionary History as a schoolgirl and is very pleased to have found work in such an important place.

평양에 온것을 환영합니다.

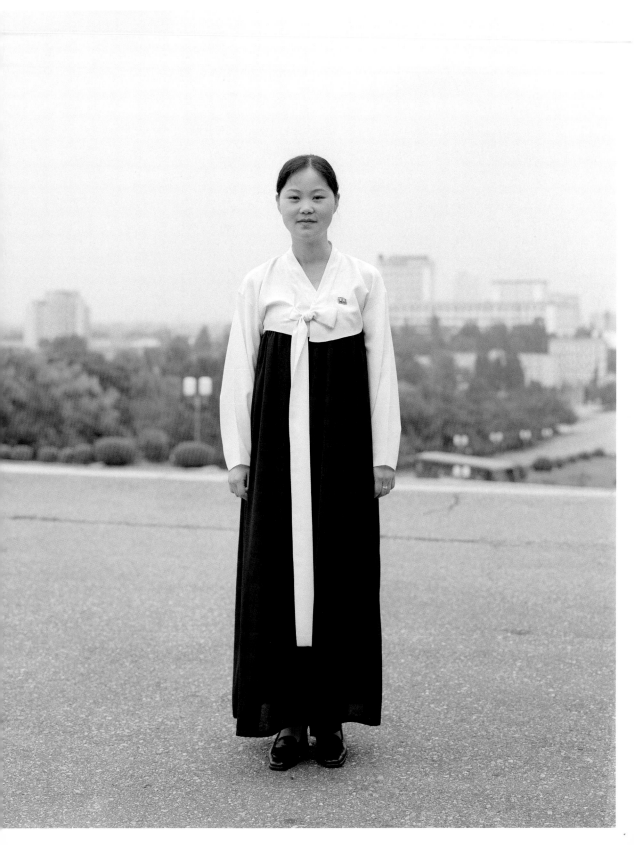

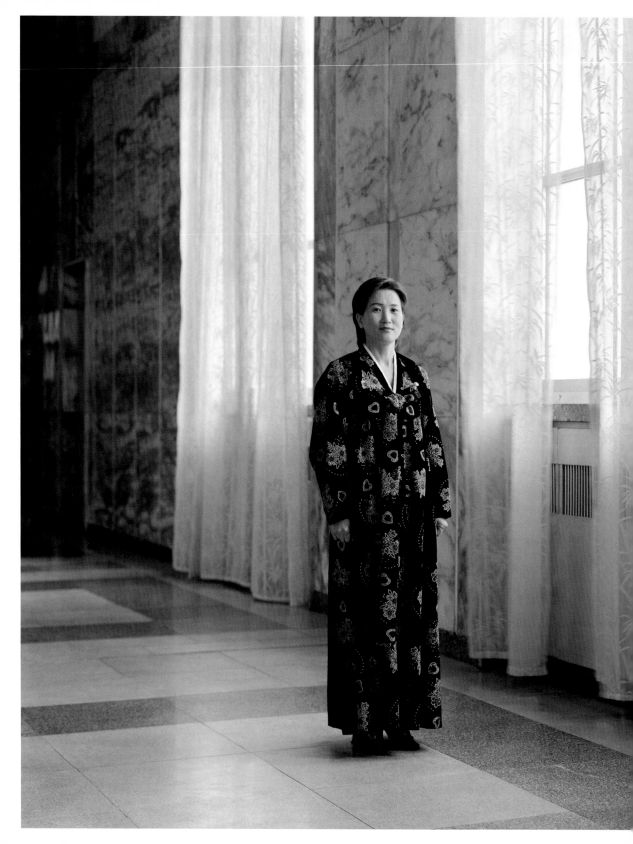

The Korean Revolution Museum

The guide is wearing a traditional dress but in a modern style. She has been working at the museum for several years and knows the museum very well. It has 54,000 square metres of exhibits in over 90 exhibition halls, including two projection rooms and several big cycloramas. The museum is very important to teach Korean schoolchildren about our revolutionary history – about the anti-Japanese struggle, the democratic revolution, the Fatherland Liberation War, the building of socialism and the struggle for the peaceful reunification of our country.

Ice Rink

This is the guide for the Ice Rink and she will show you around the building. The Ice Rink is cone shaped like a skater's hat. We hold regular ice hockey matches here, and each February the Ice Rink hosts the International Figure Skating Festival where skaters compete for the Paektusan Prize. We use a lot of marble in our architecture as it is a beautiful, strong material which occurs naturally in our country.

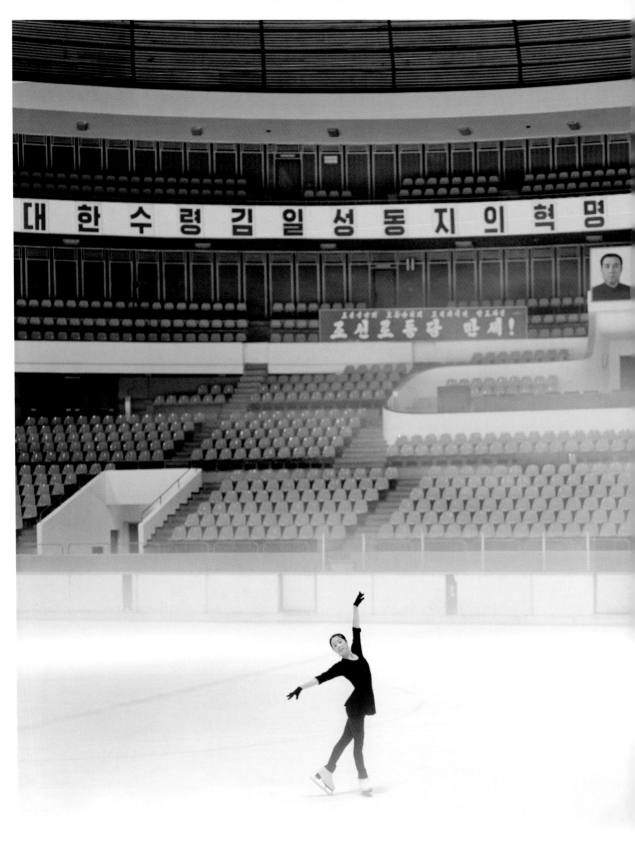

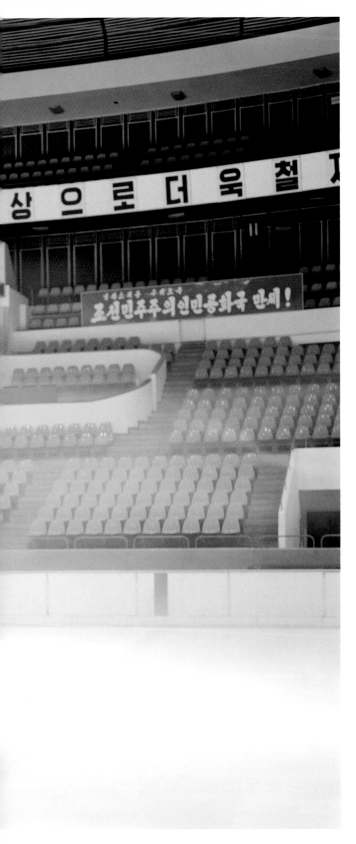

Ice Rink

Miss Lim is nineteen years old and is a member of the Pyongyang Winter Sports Team. She has spent eight years learning and she is hoping to be in the 2010 Winter Olympics in the competition for single figure skating. I am not an expert but I think she skates very beautifully. We hold the International Figure Skating competition in our country each year under the ideas of Independence, Peace and Friendship. When I was young, winter was much more severe and the rivers and ponds were frozen for longer. My father made me a wooden board with a single metal blade and two wooden poles with metal spikes to push with, and we would rush across the ice.

Kangson Steelworks Statue

Near to Pyongyang ice rink we have some statues
which represent certain proud moments of our
people. This statue shows the heroic workers of
the Kangson Steelworks and the image is from the
song and dance performance *Song of Paradise*.
At the steelworks the smelters achieved miraculous
successes, holding the red banner of the Three
Revolutions high. The sculpture depicts the honour
and the joy of the smelters. Our country's most
famous artist, Jong Yong Man, painted a very well-
known picture, *Evening Glow of Kangson*, which
depicts the beautiful scene around the steelworks.

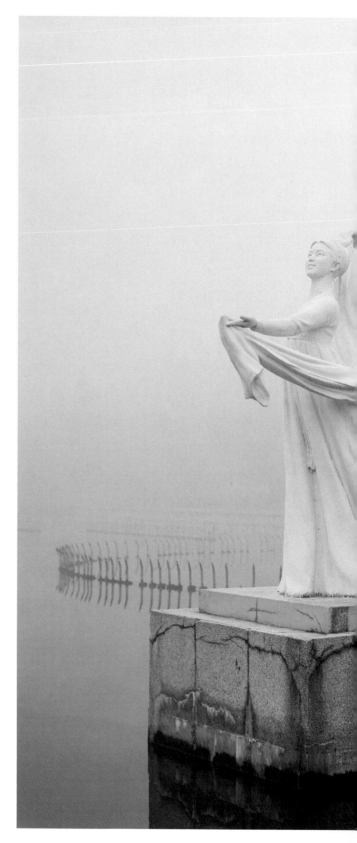

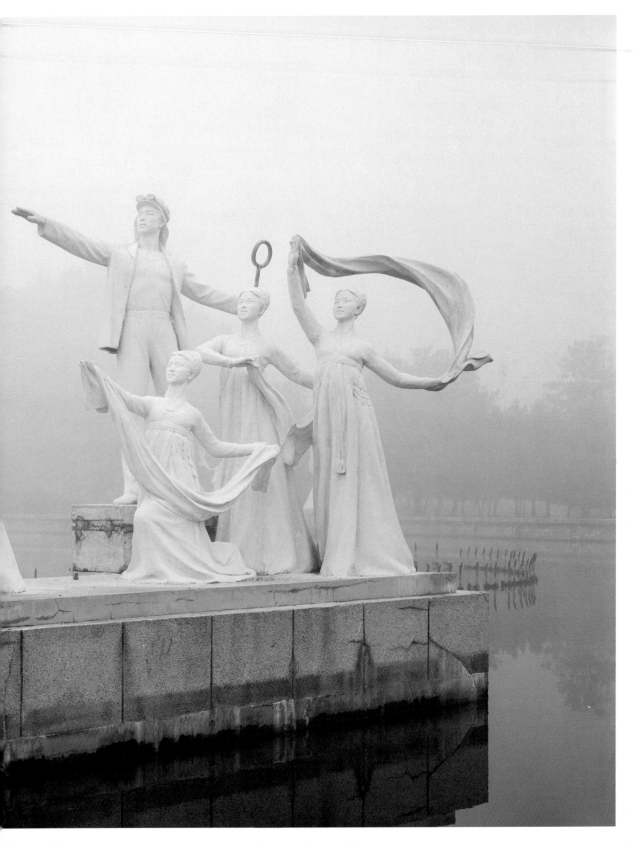

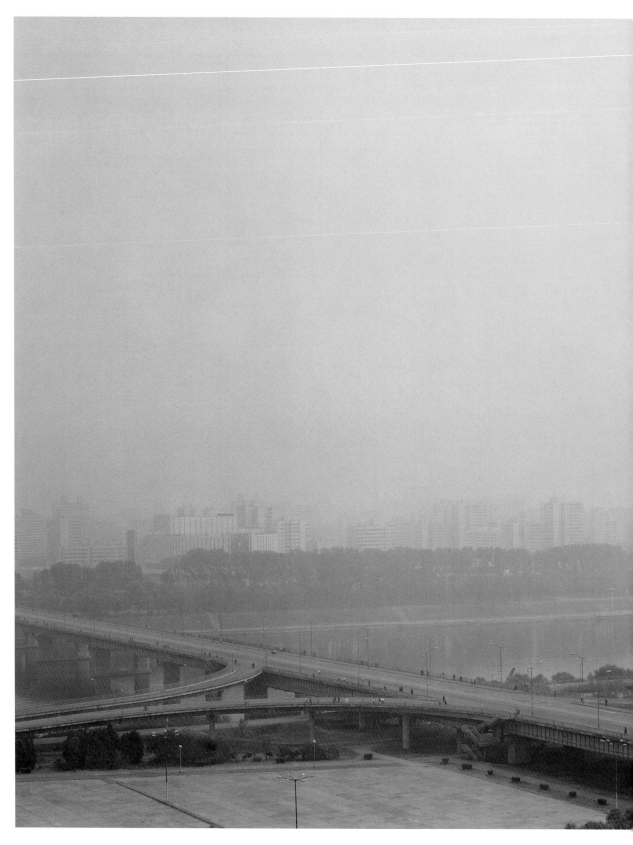

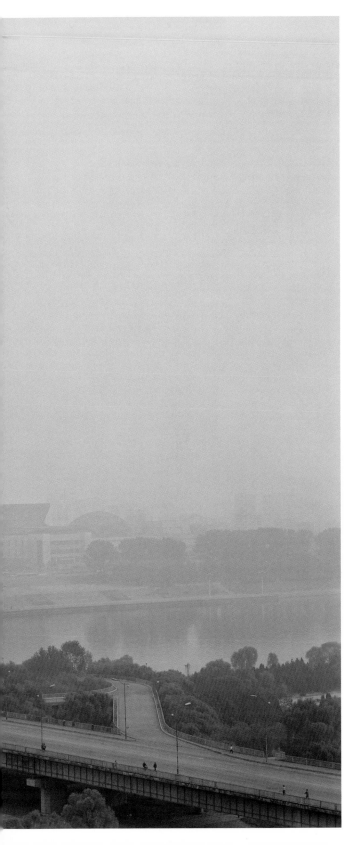

Rungna Bridge

There are several bridges over the Taedong River in central Pyongyang. The ancient Korean term 'pyongyang' refers to a plain with a large river, ideal for agriculture and habitation. We say we are from the land of the morning calm. Pyongyang was once called the 'capital of willows' as it is so well suited to these trees, and they can be found in many places throughout the city. This bridge crosses from East to West Pyongyang, over Rungna Island where the May Day stadium is located. My home is on the east side and if I am on my bike I cross this bridge to get to work.

Welcome to Pyongyang
By Charlie Crane
Introduced by Nicholas Bonner
© Chris Boot Ltd 2007

First published 2007 by Chris Boot

Chris Boot Ltd.
79 Arbuthnot Road
London SE14 5NP
United Kingdom
Tel. +44 (0) 20 7639 2908
Fax +44 (0) 20 7358 0519
info@chrisboot.com
www.chrisboot.com

Photographs and text © Charlie Crane /
Koryo Tours
www.charliecrane.co.uk
www.koryogroup.com

Project Editor Bruno Ceschel
Design SMITH, Karl Shanahan
www.smith-design.com

The authors and publisher would like to
acknowledge and thank the Korean International
Travel Company and the guides Mr Li, Mr Kim,
Mrs Pak and Mr Oh; Simon Cockerell, Joshua Green,
June Bonner, Hannah Barraclough and Emily
Qiu of Koryo Tours; Bayeux and Spectrum
Photographic; Terry Hack, Martin Parr,
Servanne Sohier and John Wood.

Distribution (except North America) by
Thames & Hudson Ltd
181 High Holborn
London WC1V 7QX

A CIP catalogue record for this book is available
from the British Library.

ISBN 10: 1-905712-04-9
ISBN 13: 978-1-905712-04-5

Printed in China

평양에 온것을 환영합니다.